IMAGES
*of America*

# MARBLEHEAD
## VOLUME II

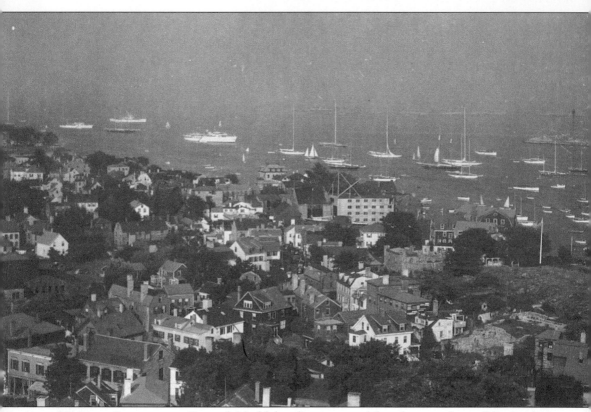

**HARBOR PANORAMA.** One of Marblehead's most prolific photographers, F.B. Litchman, captured this view of the town and its picturesque harbor that he titled "Yesterday, Today, and Tomorrow." The photograph was taken from the tower of Abbot Hall, which was built in 1876–1877 on Training Field Hill. (*Circa* 1910 detail of photograph by Fred B. Litchman, 1869–1945; courtesy Charles F. Maurais.)

# IMAGES
## of America

# MARBLEHEAD
## VOLUME II

John Hardy Wright

ARCADIA

First printed in 2000.

Published by Arcadia Publishing,
an imprint of Tempus Publishing, Inc.
2 Cumberland Street
Charleston, SC 29401

Printed in Great Britain.

Library of Congress Catalog Card Number: 97-149487

For all general information contact Arcadia Publishing at:
Telephone 843-853-2070
Fax 843-853-0044
E-Mail sales@arcadiapublishing.com

For customer service and orders:
Toll-Free 1-888-313-2665

Visit us on the internet at http://www.arcadiapublishing.com

This book is dedicated to the memory of Harry Wilkinson (1908–1999), a cheerful chronicler of Marblehead's history, known affectionately, and in his writings, as "Mr. Whip." (Courtesy Norman W. Powers.)

# CONTENTS

**MARBLEHEAD, C. 1935.** This polychrome wood block print is by an unidentified artist. (Courtesy Nathalie Frost Woods.)

*You should come to Marblehead where*
*there's still a soft suggestion*
*Of the romance and the pathos*
*that lie buried with her dead.*
*Where there's still a touch of quaintness*
*and the making of a story*
*In the crooked streets and by-ways*
*in the Port of Marblehead.*

—Wallace Dana Weed, the "Poet Postman" (1871–1945)

# INTRODUCTION

The "sacred cod"—which is represented today as a weathervane on the Old North Congregational Church in Marblehead—was what brought transient fishermen from England's West Country to the northeastern shore of Massachusetts Bay in the early 17th century. Some of those rough and briny men stayed on to found "Marvell Head" in 1629, no doubt cognizant of the protective harbors and coves where they (and many of their descendants) erected "fish flakes" to dry the cod and other fish on wooden frames in the fresh air and sun.

During the 18th century, vessels of different sizes—laden with fish and timber—sailed to ports in the West Indies, England, and Spain, where their savvy captains engaged in mercantile trade that netted huge profits for the ships' owners, enabling them to build impressive homes in the town. Trade with Europe and with ports in Asia and the Pacific in the early 19th century—especially after the War of 1812—brought exotic objects, such as marble-veneered mirrors, porcelains, and other items to fill the various rooms of the merchant princes.

The "fishery" and its related businesses comprised the main occupation of the inhabitants, through various periods of growth or stagnation, up until 1846. On September 19 of that year, an unexpected and severe gale off Newfoundland's Grand Banks wiped out half of the town's fishing fleet, taking with it 65 men and boys.

Never to recover as a fishing port, Marblehead's work force turned to manufacturing shoes; footwear had been made off-season in small "ten-footers" on residents' property. Shortly thereafter, large wooden factories were built, augmenting neighboring Lynn's top industry. However, after two back-to-back devastating fires in 1877 and 1888, the manufacturing center of town never again supported shoemaking or any major industry in Marblehead.

Turning once more to the surrounding waters for their livelihood, many "'Headers" began catering to the summer visitors who were vacationing in growing numbers in the burgeoning inns and hotels along the town side of the harbor. The tourists craved fresh seafood dinners in attractive restaurants in the Fort Beach area near the pleasantly walkable Fort Sewall, with its breathtaking views of the "Great Neck," the harbor, and the islands.

Marblehead Neck was discovered as a summer resort in the 1860s, initially by campers from Lowell, Massachusetts, and Nashua, New Hampshire. These campers set up white tents on the Atlantic Ocean side of the island-turned-isthmus. Farsighted individuals soon purchased plots of land and erected Victorian cottages for their families to enjoy during the brief summer season; more often than not, these were eventually enlarged or remodeled into prestigious estates with year-round amenities.

Yachting, the sport of the wealthy, revolved around the maritime activities of yachting clubs, which were founded by different old Yankee groups: the Eastern Yacht Club (1870); the Corinthian Yacht Club (1885); and the Pleon Yacht Club (1887), the first junior yacht club established in America. These clubs were built on the inner side of the Neck. The Marblehead Yacht Club (1878) was built on the town's shore, as were the Boston Yacht Club (1902)—which set up this station apart from its city location—and the Dolphin Yacht Club (1951)—which was formed by members of the growing Jewish community.

In the late 19th century and through the 1930s, Marblehead was recognized as the "yachting capital of the world." Local vessels competed with those from various non-local yacht clubs to win trophies for their prowess and speed, as they have continued to do so since then.

Today, the harbor still thrives with related maritime activities, including fishing, lobstering, and sailing. During Race Week, usually held toward the end of July and early August, sleek yachts can be seen in the harbor vying against each other. But at any time, locals and visitors can enjoy the beauty of a picture-perfect day, with perhaps a few wispy clouds passing overhead and sunshine reflecting off the crisp, white sails on the horizon.

*Author's note:* The images in this book relate to the harbors and shoreline of the town and the Neck. Those in the first chapter are arranged clockwise (for the most part), beginning with Naugus Head and ending with the Clifton shore. Quotation marks around an image's title indicate a known or given name for a photograph, postcard, or locale; other titles were fabricated. Selected examples of the town's architecture and much of its social history are represented in *Marblehead Volume I*, published in 1996. Images in a credit line not attributed to an owner are from the author's collection.

A SOUVENIR POSTCARD, C. 1908. Generic postcards printed in polychrome—with a distinctive image and a locale's name or place of business—appealed to tourists and collectors in the past, as they do today. (Courtesy Maurais Collection.)

# One

# SHORE AND
# HARBOR VIEWS

**DETAIL OF AN 1872 MAP OF MARBLEHEAD.** The land mass of the town, or mainland, is 4.4 square miles, and the smaller, asymmetrical Great Neck is composed of 300 acres; the area was called "Marble Harbour" in William Wood's 1634 publication *New England's Prospect.* In 1839, John Warner Barber, author and artist of an early volume on the history of Massachusetts cities and towns, wrote that Marblehead Harbor is "deep and excellent, capable of being entered at all times by ships of the largest size." This very attractive harbor is situated northeast and southwest for a distance of about one-half mile.

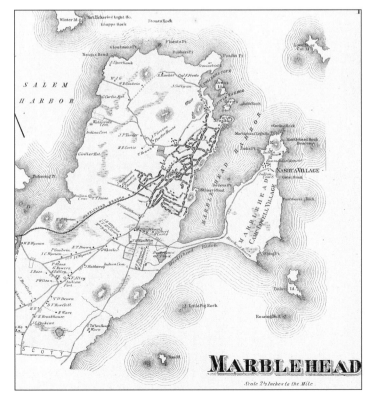

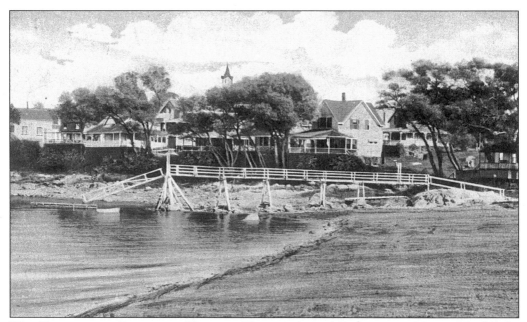

THE BEACH AND COTTAGES, NAUGUS HEAD, C. 1915 POSTCARD. "Nogg's Head," the geographical term used in England for a headland's angle to a stream—in this instance, Forest River—became Americanized (Naugus Head) for this area, situated on the Salem Harbor side of Marblehead. People who built their Colonial Revival–style residences off West Shore Drive in the 20th century liked the architectural charm of "Old Town" (a term used mainly by realtors), but they preferred more open space to raise their families. (Courtesy Mr. and Mrs. Robert Swift.)

THE SLEE FAMILY AT THEIR NAUGUS HEAD COTTAGE, C. 1908. Charles A. Slee, a real estate agent whose office was at 3 School Street in the Gregory Building, stands in the foreground next to his son Ackley. Bella Hardy Slee, Ackley's mother, stands at the bottom of the stairs by a hand-painted whirligig figure. (Courtesy Mrs. Richard Slee.)

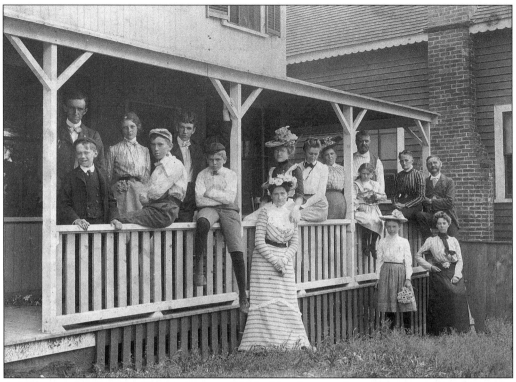

**A NAUGUS HEAD GET-TOGETHER, c. 1900.** Members, and possibly some friends, of the Swasey and Parker families gather in their turn-of-the-century finery on the porch of the Swasey family's summer cottage. Martha Elizabeth Parker (the young lady second from the left in the back row) and her relatives and friends were photographed on the same summer day in a nearby pasture with a horse (see *Marblehead Vol. I*, p. 73). (Courtesy Mrs. Samuel E. Swasey.)

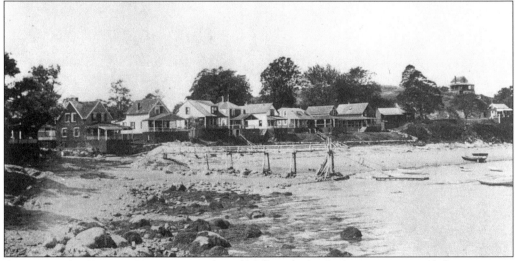

**CLOUTMAN'S POINT.** Naugus Head and Cloutman's Point cottages and houses were constructed at about the same time. Although built closely together, the summer residences are oriented, for the most part, toward the ocean's vistas. (Early-20th-century photograph; courtesy Swasey Collection.)

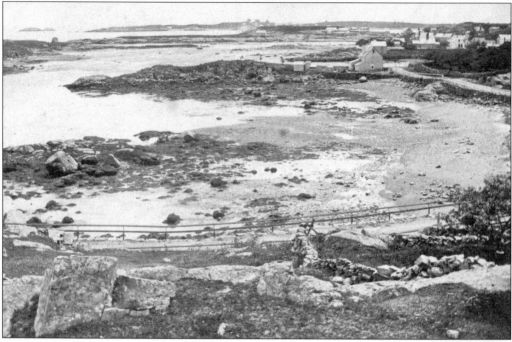

GRACE OLIVER'S BEACH, DOLIBER'S POINT. Located off Beacon Street and Crowninshield Road, this beach has been associated for generations with the woman who owned the large, gambrel-roof house there. Grace Oliver was a cofounder with Mary A. Alley of the Marblehead Visiting Nurse Association. "Barnegat" (in the distance) is the oldest residential section of the town and is where the "fishery" was established in the early 17th century. (Late-19th-century stereo view; courtesy Benjamin R. Chadwick.)

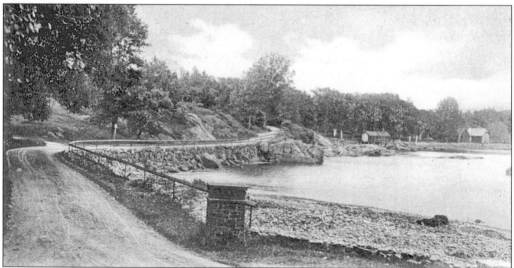

THE ENTRANCE TO PEACH'S POINT. Crowninshield Road, the designated name at the entrance of the private peninsula in the Little Harbor area, is named for Francis Boardman Crowninshield, the Boston businessman who, in 1871, purchased a large section of land on the point named for the 1630s English inhabitant John Peach. Crowninshield family descendants still reside there along with other families. (Early-20th-century postcard; courtesy Maurais Collection.)

**LITTLE HARBOR.** The trappings of lobstermen appear near or on the small, shingled shanties of their humble owners, while the larger and fancier abodes of privileged people who bought and enjoyed the crustaceans are on Peach's Point in the background, and in other areas of the charming town. Brown's Island is the rocky promontory at the right. Marine photographer Willard Bramwell Jackson was a rather brusque individual who retired from an English steel company and arrived in Marblehead, where he devoted his time and energy to documenting the local scene. He made or assembled his own large tripod camera, which he used with a black hood, and took at least 3,378 photographs, many glass-plate negatives of which are in the collections of the Peabody Essex Museum in Salem, Massachusetts. (1899 photograph by Willard B. Jackson; courtesy Marblehead Historical Society.)

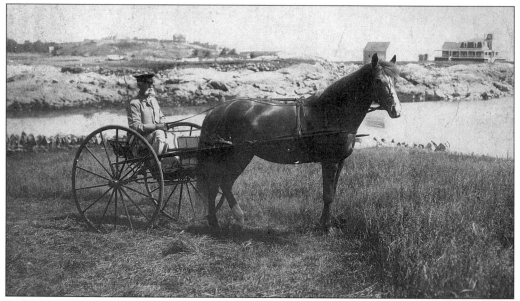

**A Buggy Ride in Little Harbor.** In this *c.* 1895 photograph by Willard B. Jackson, William E. Brown, who resided at 124 Front Street, enjoys a ride in a part of the town that he has known probably all of his life. The larger of the two houses on Gerry's Island was painted yellow and white and featured a wraparound piazza before it was destroyed by fire around 1969. It was the summer home of two Roman Catholic priests, thus giving the island the often used name of "Priests' Island." Brown's, or Crowninshield Island (in the background), was named to honor its donor, Louise DuPont Crowninshield. It is now owned by the Massachusetts Trustees of Reservations. (Courtesy Mr. and Mrs. Frederick W.E. Cuzner.)

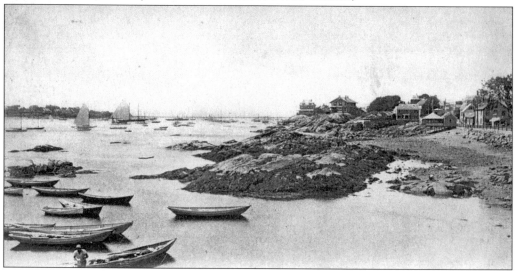

**Little Harbor from Brown's Island, Early 20th Century.** Fishermen's homes, shanties, and shacks line the serpentine shore, with boats always in or out of the water, in the picturesque area where Orne and Beacon Streets meet. A boatyard had been established in Little Harbor as early as 1636, and the *Desire*, a vessel of 120 tons, was built and launched there that year. Cradleskid Lane is the fascinating name of the narrow passageway off Beacon Street. (Courtesy Vincent F. McGrath.)

**A Denizen of Little Harbor.** An unidentified urchin leaning against what may be a relative's dory appears lost in thought as she gazes past her Victorian doll carriage with its doll and stuffed animal. This provocative low-tide scene resembles a still from an early film. Photographer Parker captured many such views in the town where he, his parents, and siblings resided around the turn of the century. Redgate, their summer home on Marblehead Neck, is illustrated and described in chapter 4. (1892 photograph by Herman Parker, 1866–1946; courtesy Marblehead Historical Society.)

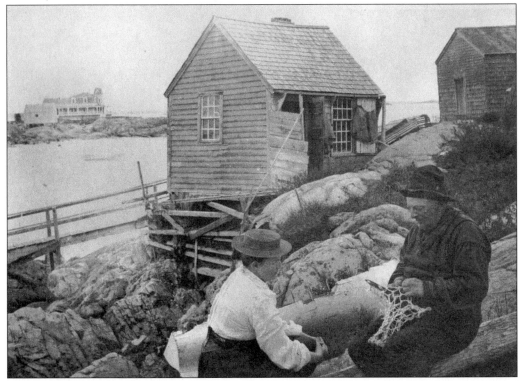

**Making Lobster Pots and Traps.** A well-dressed young lady watches the skillful hands of "Sano" Standley as he performs a necessary work-related task. Standley, a photogenic lobsterman and fisherman, lived as a recluse in the precariously perched shanty on the southern side of Little Harbor around the turn of the century. The similarly photogenic shingled shanty, now long gone, was often referred to as Marblehead's "Motif No. 1" by artists and photographers. (1892 photograph by Herman Parker; courtesy Mr. and Mrs. Alexander Parker.)

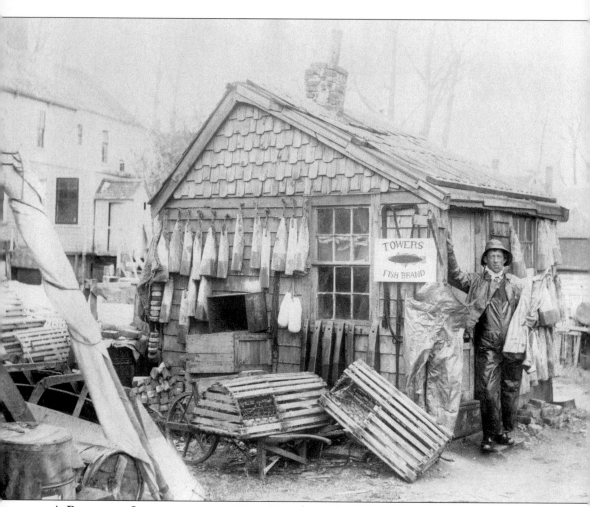

**A BARNEGAT LOBSTERMAN, C. 1910.** Considering his first and middle names, one imagines that Grover Cleveland Luscomb's parents may have had higher aspirations for their son. However, he found his niche in life as a contented lobsterman. The young man strikes a casual pose with his corncob pipe by a shingled lobster shanty thought to have been located behind the early house at 7 Beacon Street in Little Harbor. A fishmonger's sign has a prominent spot on the one-room picturesque building, which has at least two sliding sash windows, a narrow door, and a tilted and patched brick chimney. A wheelbarrow with semicircular wooden lobster traps, painted and well-worn markers, and crates and barrels all indicate the occupant's profession. The oilskin slicker (undoubtedly yellow) hanging up to dry, and the one held by Mr. Luscomb, are stenciled by the manufacturer "Superior/Frost" for David O. Frost of Gloucester, Massachusetts. (Courtesy Chadwick Collection.)

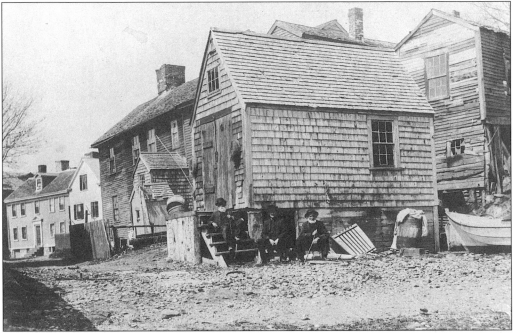

MARBLEHEAD CRONIES AT GAS HOUSE BEACH, C.1895. One of the town's intriguingly named buildings, the "Old Spite House," is the unpainted, clapboard-framed structure with the neglected chimney in the center of the picture. Three elderly gents sit in front of a shed or shanty next to the narrow path that leads from Orne Street to the harbor. During the late 19th and early 20th centuries, large coal barges came into this area; coke and coal were processed to make gas for lighting streets, houses, and businesses before the advent of electricity. (Courtesy Dorothy Fogg Miles.)

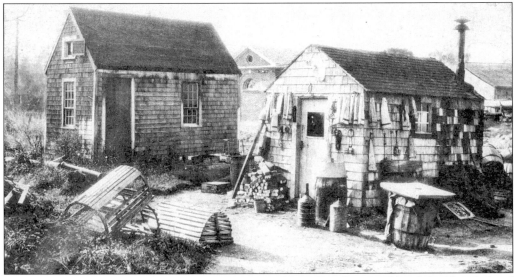

LOBSTERMEN'S SHANTIES, C. 1930S POSTCARD. The Colonial Revival brick building behind the colorful one-room wooden shanties is a sewer pumping station that was built around 1927. It is located in the Fort Beach area on narrow Fort Beach Way adjacent to the turn-around and small parking lot. (Courtesy Swift Collection.)

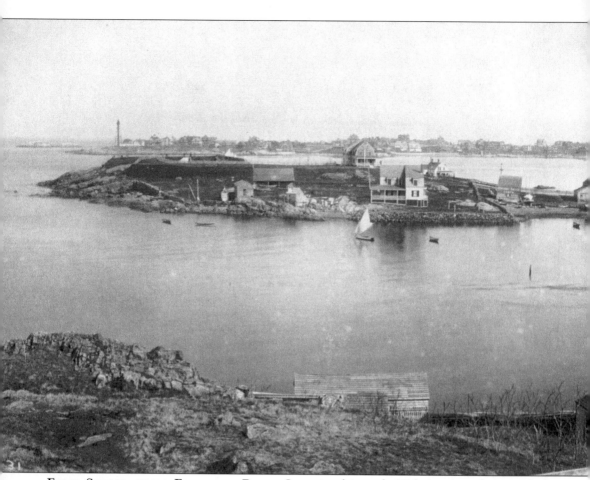

**FORT SEWALL FROM FOUNTAIN PARK.** Seen in this early-20th-century photograph by Willard B. Jackson, Fountain Park off Orne Street is the second highest point of land in the Little Harbor area. It was known previously as Bailey's Head. During the Revolutionary War and the War of 1812, it was the site of Fort Washington. Fort Sewall—the bulwark built in 1742 and named in 1814 for Chief Justice Samuel Sewall of the Massachusetts Supreme Court—is situated behind the wooden fence at the tip of Gale's Head. Randomly sited houses and fishermen's shanties dot the land mass, including Sano's shanty in the center on the rocks. The old Fish House, which was painted barn-red, is at the far right. In the distance at the tip of Marblehead Neck is the 1896 steel light tower, or lighthouse. To the right of that beacon are the many fashionable homes and yacht clubs of the town's well-to-do residents. (Courtesy Marblehead Historical Society.)

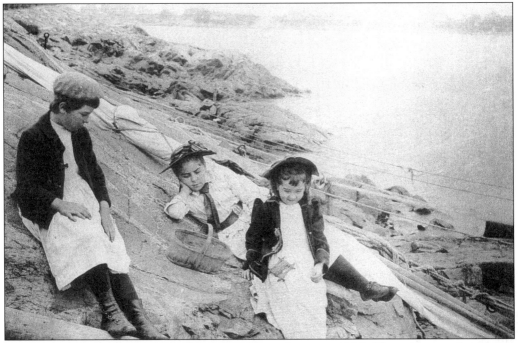

**FISHERMEN'S CHILDREN ON THE ROCKS AT FORT SEWALL, 1892.** Three bonneted girls, one of whom emulates her father's occupation with a fishing reel, pose on a smooth section of ledge next to a sail-wrapped mast. Herman Parker's best pictures were included in a limited-edition, leather-bound book that he published privately at this time. (Courtesy Parker Collection.)

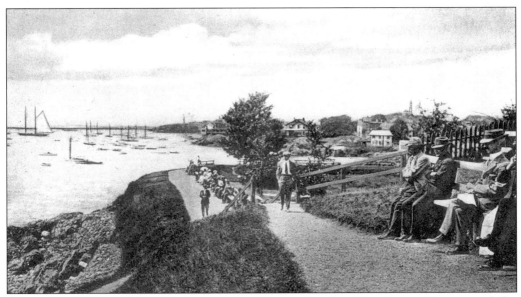

**A SCENE AT FORT SEWALL, C. 1910 POSTCARD.** People still enjoy walking around the promenade and perching on the fort's wooden benches, with panoramic views in all directions. The Causeway that connects the town of Marblehead to Marblehead Neck is visible in the distance at the end of the harbor. (Courtesy Maurais Collection.)

**ALONG FORT BEACH, FRONT STREET, C. 1905.** This image predates the 1908 construction of the Adams House Restaurant between the two smaller restaurants on wooden pilings. The dwellings on the other side of the street, including the 17th-century "Old Pirate Cottage" (with only a portion of its roof visible), were torn down in the early 20th century to make way for other restaurants and gift shops. (Courtesy Chadwick Collection.)

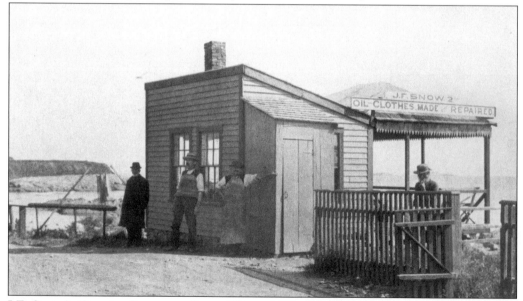

**J.F. SNOW'S OILSKIN CLOTHING SHOP.** This *c.* 1900 photograph shows Front Street near the former terminus of the Boston & Northern Street Railway. When Joseph F. Snow II decided to change hats from making and repairing fishermen's oilskin clothing to catering to the growing "hungry tourist" trade, he enlarged this small structure and added a one-room second story along the street, probably for his residence. Snow's Ocean House Café featured reasonably priced fare for those going to Fort Sewall. (See *Marblehead Vol. I*, p. 103; courtesy Chadwick Collection).

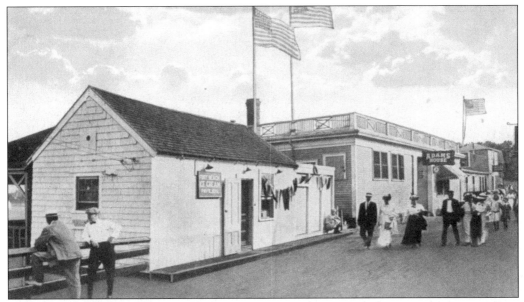

THE ADAMS HOUSE, FRONT STREET NEAR THE CORNER OF SELMAN STREET, C. 1910 POSTCARD. Nestled between the Fort Beach Ice Cream Pavilion and Joseph Snow's Ocean House, the Adams House was a trendy restaurant that grew in popularity with the addition of a second story, as this small stretch of eateries and souvenir shops became more accessible by auto and trolley. The restaurant's first owner, and former fire chief John T. Adams, was the publisher of this postcard. (Courtesy Swift Collection.)

THE BAY VIEW GUESTHOUSE, 21 GOODWIN'S COURT, C. 1947 POSTCARD. Each day during the season when this prominently situated guesthouse adjacent to Atkins' Beach was open for business, the proprietors proudly raised the American flag for all to see. The Burgess Yacht Club, which was established in 1892 in memory of yacht designer Edward Burgess (1848–1891), was located at 11 Goodwin's Court before it merged with the nearby Boston Yacht Club in 1902. (Courtesy Maurais Collection.)

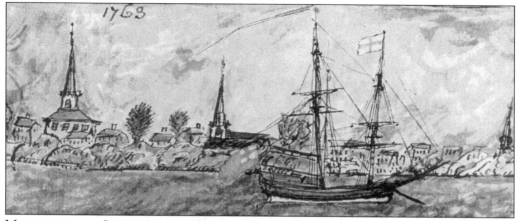

**MARBLEHEAD AS SEEN FROM THE HARBOR.** In this 1763 watercolor by local mariner Ashley Bowen (1728–1813), a Portsmouth, New Hampshire, vessel, the brig *Success*, sails past three of the town's early houses of worship. The buildings are, from left to right, St. Michael's Church on Summer Street, the New Meeting House on Franklin Street, and the Old Meeting House on Old Burial Hill (the latter two no longer standing). This small, whimsical image is the earliest known representation of Marblehead and its harbor. Three years later, in 1766, there were between 20 and 40 merchants and scores of ships, brigs, snows, and topsail schooners involved in foreign trade and fishing. (Courtesy Marblehead Historical Society; on deposit at the Peabody Essex Museum.)

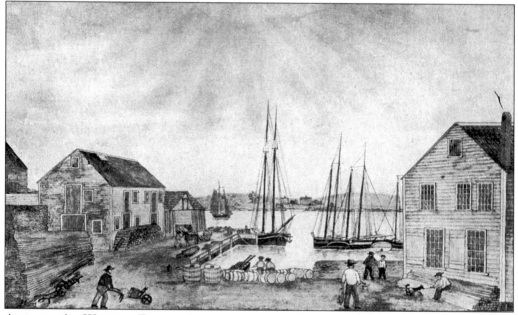

**APPLETON'S WHARF, FRONT STREET AT THE FOOT OF STATE STREET, C. 1850 WATERCOLOR.** Stacks of lumber, firewood, and a group of barrels made by a cooper dot the area around the busy wharf. Before the Revolutionary War, State Street was known as King Street to honor the first three Hanoverian Georges. Ben B. Dixey owned the wharf after Appleton's departure from the scene; Dixey was in the wood and coal business until 1884. (Courtesy Marblehead Historical Society.)

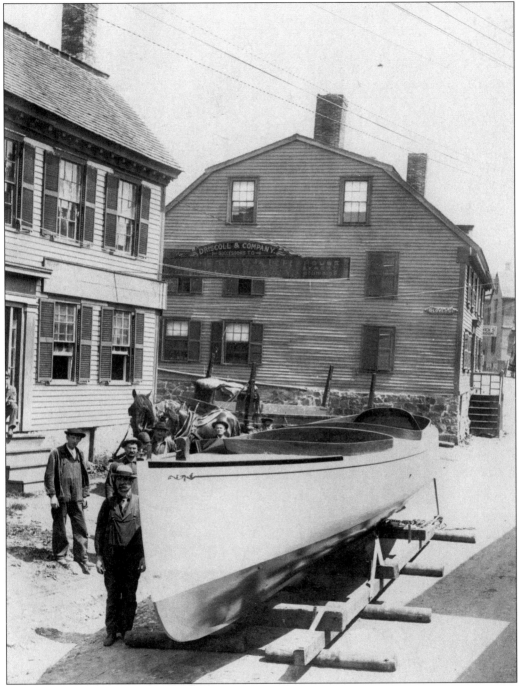

MARTHA AND 'HEADERS, THE CORNER OF FRONT STREET AND GLOVER SQUARE, C. 1905.
Proud of the motor launch they have built, these workmen pose with the team of horses necessary
to transport the boat from the boatyard to the wharf of the purchaser. The wide, gambrel-roofed
house in the background was the popular Three Cods Tavern, which received a shot from the
British frigate *Lively* when she was in the harbor in 1775. (Courtesy Chadwick Collection.)

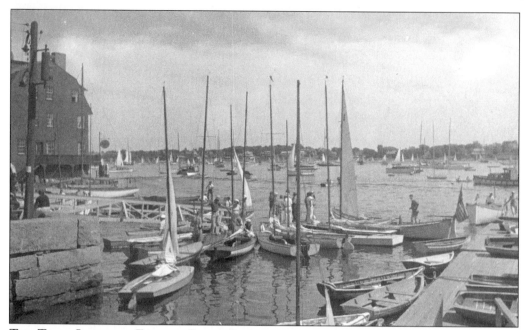

THE TOWN LANDING, FOOT OF STATE STREET, C. 1930S PHOTOCARD. Always the location of much maritime-related activity, the Town Landing–State Street Landing today is used by skippers who tie-up their vessels temporarily and by lobstermen who bring in the daily catch. The large building at the left was moved across Front Street around 1925, according to a local nonagenarian, and it was operated as a boardinghouse by a Mrs. Cann. (Courtesy Mr. and Mrs. James R. Hammond.)

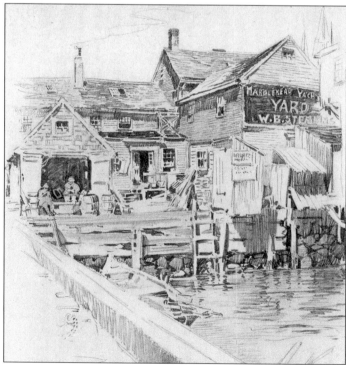

ON THE WATERFRONT, 1906. William B. Stearns owned the Marblehead Yacht Yard at 89 Front Street until around 1902, when George T. McKay joined him as a partner. James Elbridge Graves later acquired the business, and it was known as the Graves Yacht Yard until it was sold by the family in 1981. This image is one of many made by Hornby that were included in *An Artist's Sketch-Book of Old Marblehead*, with text by Sylvanus Baxter. (Lithograph by Lester G. Hornby, 1882–1956; courtesy Swift Collection.)

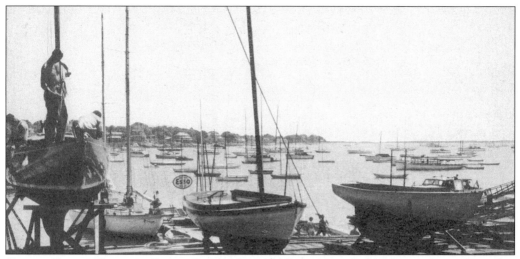

GRAVES YACHT YARD, 91 FRONT STREET, C. 1935 POSTCARD. Referred to as the yacht yard or boatyard, this was the main location of the family-owned business; their lower boatyard was at Little Harbor off Beacon Street. The *Nefertiti*, built in an amazing 96 days at the yacht yard, was designed by Ted Hood, one of the top sailmakers in the United States. Unfortunately, she failed to become the country's defender in the America's Cup race of 1962. (Courtesy Maurais Collection.)

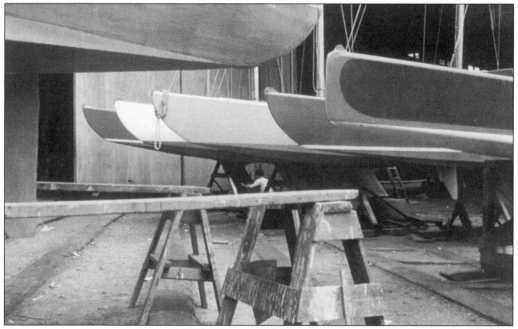

"STUDY IN LINE," GRAVES YACHT YARD, C. 1955. An employee of the firm inspects the fin keel of one of the 210-class racing sloops in storage. The 210-class and 110-class of sloop (an example of the latter is at the right) were designed by C. Raymond Hunt, a broker and yacht designer at 79 Front Street around 1950. These racing sloops were the earliest sailboat classes, designed to be fabricated from sheets of plywood; all were built by the Graves company and other licensed builders. The photographer, Miss Eleanor Broadhead, a former Saltonstall School kindergarten teacher in Salem, took this prize-winning photograph, which was included in an exhibition that traveled to many countries.

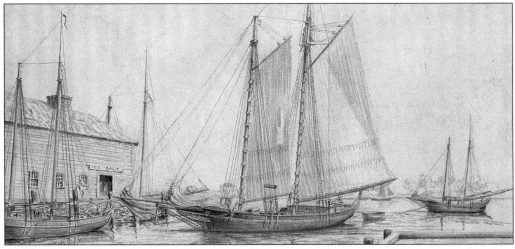

**RETURNING TO PORT, EARLY-1940S PENCIL DRAWING.** The two-masted schooner *Carrie A. Pitman*, which was christened in 1867, is shown approaching a wharf at the site of the present State Street Landing. In the right background is a pinky, a double-ended forerunner to the fishing schooners of the early 19th century. Duties on incoming cargoes were paid at the town's customhouse, located alternately at two locations on Front Street and at 61 Pleasant Street, where Joseph W. Coates was the deputy collector and inspector in 1914. (Drawing by John F. Leavitt, 1905–1974; courtesy Mr. and Mrs. Norris L. Bull Jr.)

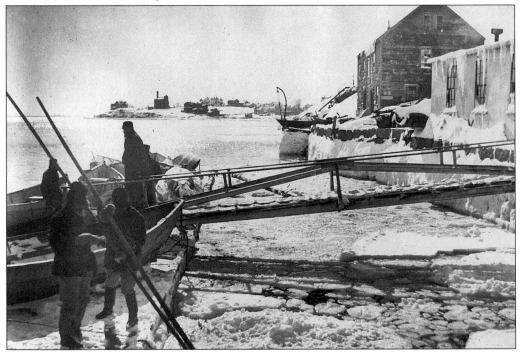

**BREAKING ICE NEAR THE TRANSPORTATION BUILDING ON TUCKER'S WHARF, C. 1900.** Many deep freezes have blocked the harbor in the past. These men would like to go fishing in their dories, but first must dislocate the ice with their long, wooden poles. The mid-18th-century Transportation Building, one of the earliest remaining maritime-related structures on the New England coastline, had its peaked roof removed around 1905. (Courtesy Chadwick Collection.)

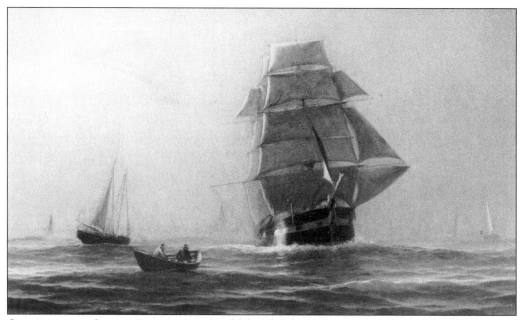

**CROSSING THE GRAND BANKS.** Any Marblehead fisherman "worth his salt" sailed either as a boy (in the capacity of a cook or his helper) or as a man to catch cod and other fish at the Grand Banks off Newfoundland for extended periods of time. In 1768 and 1769 alone, 23 fishing vessels and their crews were lost at sea. The greatest tragedy, however, occurred during the Great Gale of 1846, when 11 fishing schooners carrying 65 men and boys were lost at the fishing grounds. (1876 oil painting on canvas by William E. Norton, 1843–1916; courtesy Town of Marblehead; on view at Abbot Hall.)

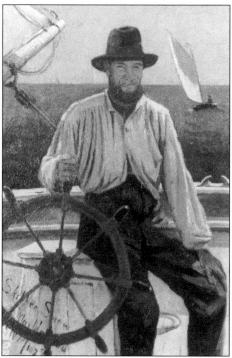

**CAPT. JOSEPH F. SNOW ON THE LUCY E.** Skipper Snow, who resided on Front Street near Selman Street in the 1880s, sat appropriately at the wheel for this small, nautical portrait. Marblehead fishermen traditionally pitched copper pennies at Halfway Rock several miles southeast of the entrance to the harbor to assure good luck, a good catch, and most important, a safe return home. (1879 oil painting on canvas by William E. Low; courtesy Town of Marblehead; on view at Abbot Hall.)

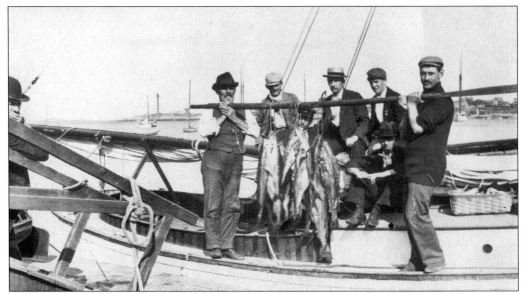

**A Successful Fishing Trip c. 1905.** Displaying their catch on an oar are Dick Caswell (far left) and Charles Goodwin (far right). Fred Litchman is the chap in the center, and Joel Reynolds is the young man to his right. The other members of the group—who were on the "Manning fishing trip," according to the back of this photograph—are unfortunately unidentified. During the 10-year period between 1765 and 1775, the tonnage of cod caught by local fishermen was 7,500. (Courtesy Chadwick Collection.)

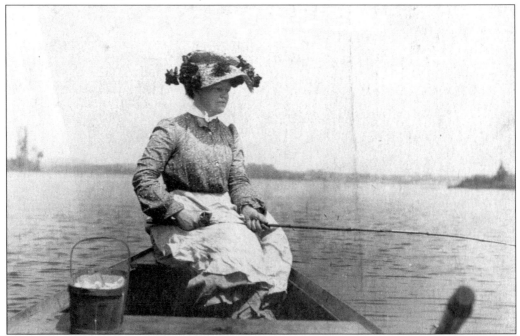

**Waiting for a Bite, c. 1905.** Clara W. Hardy, the sister of Bella Hardy (Mrs. Charles A. Slee) sits patiently with either her lunchbox, or tackle box, nearby. Clara wears a wide-brimmed hat festooned with flowers, a white neckerchief, and a large apron to make the sunny afternoon's fishing outing somewhat cooler and cleaner.

**A LOBSTER TRAP TRIO, C. 1900.** A youth and two middle-aged men who are wearing identical straw hats, striped shirts, and vests take some liquid refreshment behind a lobster trap with the Neck in the distance. 'Headers with nicknames of a nautical nature included "Rudder" Broughton, "Rock Cod" Dixey, "Go Below" Doliber, "Fish" Glass, "Lobster" Greenough, "Clam Belly" Howard, and "Crab" Snow. (Courtesy Chadwick Collection.)

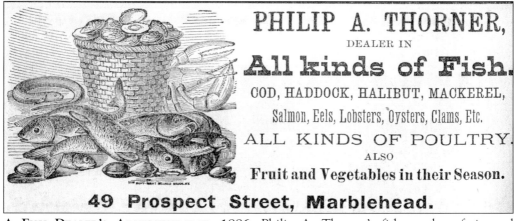

**A FISH DEALER'S ADVERTISEMENT, 1886.** Philip A. Thorner's fish, poultry, fruit, and vegetable store was located on hilly Prospect Street; seven other fish dealers were also listed in the town directory for that year. Fifty-four years earlier, on November 17, 1832, Samuel Knight of Marblehead advertised in a Salem newspaper that he had 15,000 "fall fish of the first quality" for sale for New York and Albany markets. (Courtesy Louise Graves Martin Cutler).

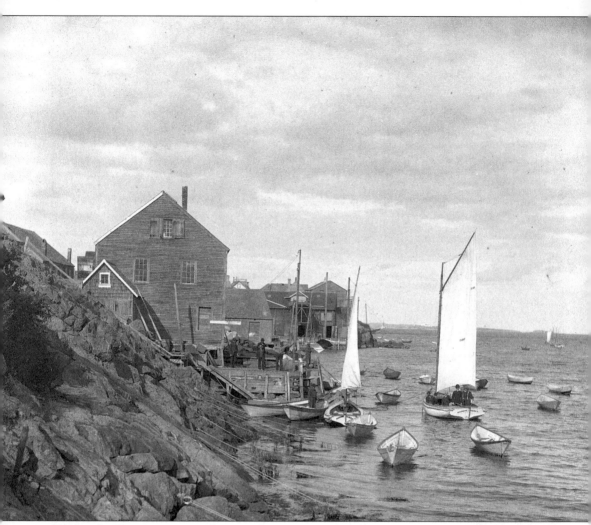

**TUCKER'S WHARF, 1892.** The Transportation Building stands on the wharf owned by the Tucker family, whose 17th-century dwelling opposite the head of Ferry Lane was regarded as the oldest house in Marblehead until it was razed sometime after 1905. Similarly photogenic was this vista with the unpainted wooden structures, the wharves, and the seaweed-draped painter lines securing the many dories. A man on the wharf is signaling a vessel in the harbor with a two-color flag. The larger of the two sailboats, the *Nanepashemet*, was named for a local 17th-century Native American sachem and the large hotel on the Neck. She has the word *ferry* stenciled on both sides of the sail. "Phil. Sheridan" is lettered on the stern of the other vessel to honor the Civil War Union general. (Photograph by Herman Parker; courtesy Russell W. Knight Collection.)

**TUCKER'S FERRY, C. 1900.** Sails were fabricated for *Grand Banks* and other vessels on the third floor of the Transportation Building (far left) until 1904, when it was acquired by the owners of the New Fountain Inn. That popular early-20th-century inn was built near the white-painted Snow family residences. (Courtesy Maurais Collection.)

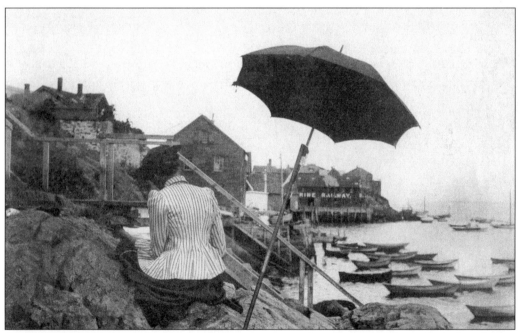

**A SUMMER VISITOR, 1892.** A jauntily positioned artist's umbrella on the rocky ledge of what is now known as Crocker Park provides shade for the unidentified artist (thought to be a New Yorker), who is concentrating on her sketchbook. Some local women artists who found inspiration in Marblehead in the early 20th century include Marian Martin Brown, Marian Huse, Ingrid Selmer Larsen, and Lillie Silver Smith. (Photograph by Herman Parker; courtesy Parker Collection.)

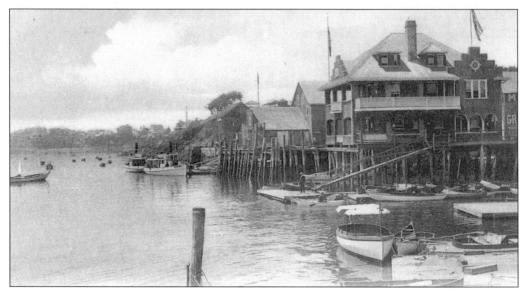

THE BOSTON YACHT CLUB (BYC), 1905 POSTCARD. Founded in Boston in 1866, the Boston Yacht Club, formerly located at 75 Front Street, opened a branch in Marblehead in 1890 for obvious scenic and maintenance reasons. The BYC has the distinction of being the oldest club of its type in New England and the second oldest in the country, after the New York Yacht Club, founded in 1844. Built in 1902 next to the Town Landing, the shingle-style clubhouse featured stepped gables, but unfortunately neither a dining room nor a bar were incorporated into the architect's plans. (Courtesy Swift Collection.)

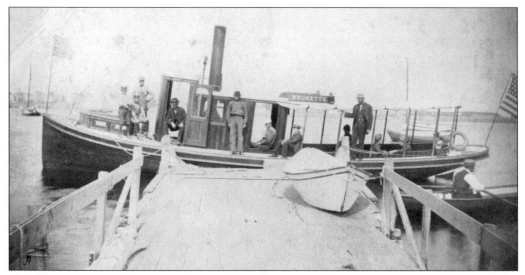

THE BRUNETTE AT DOCKSIDE, LATE 19TH CENTURY. The men, women, and boys on the steam-powered ferry resemble actors in a stage setting, frozen in time and space. W. Irving Frost, who resided in the Hawkes House on Washington Street (*Marblehead Vol. I*, p. 57) was a well-known ferryboat captain before he proudly served his country during World War I. (Courtesy Chadwick Collection.)

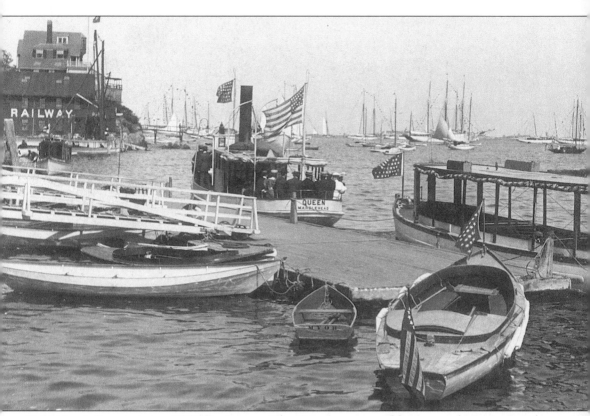

**FERRYBOAT LANDING, C. 1900 POSTCARD.** The *Queen* was one of four steam ferries operated by the Marblehead Transportation Company; along with the *Blonde*, the *Brunette*, and the *Delta* the vessel used Tucker's Wharf as a base before the name was changed to the Transportation Company Wharf. Ferries initially only made two stops at landings on the Neck, the first being the Post Office Landing. When converted to steam, they began offering harbor excursions to other ports, such as Gloucester and nearby Salem Willows, an early amusement park on the North Shore. (Courtesy Maurais Collection.)

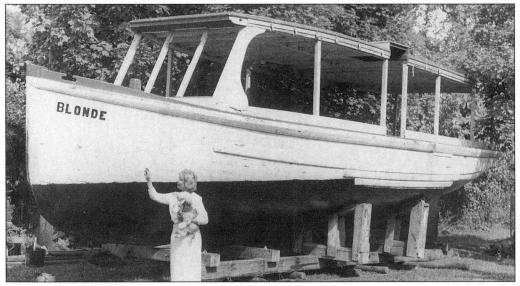

**TWO STATE STREET BLONDES, C. 1960.** Phil Woodfin acquired the last vintage ferryboat, the *Blonde*, and transported her to his property behind 16 State Street, where she remained for many years. Ariel Perry Hall, a noted harpist shown holding her poodle, Tinker Belle, later had the vessel filled with flowers and used it as a teahouse. (Courtesy Goddard Collection.)

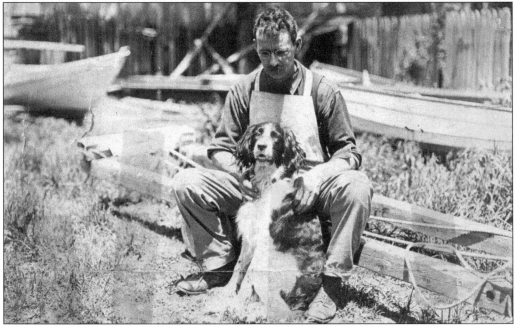

**WILLIAM H. CHAMBERLAIN AND "JACK," 14 ORNE STREET, C. 1910.** Born in Canterbury, New Hampshire, Will Chamberlain (1864–1939) later resided in the home he inherited from his uncle, George Chamberlain. Will established a boat-building shop in 1886; over the years, he developed his craft by producing the now famous "Beachcomber Dories" in a cow barn on his property. By 1915, he was building "Brutal Beasts," "J-Boats," and "Baybirds" for a new generation of sailors. Chamberlain's 14-foot rowing dories sold for $25 to over $125. (Courtesy Margaretta Chamberlain Wyzanski.)

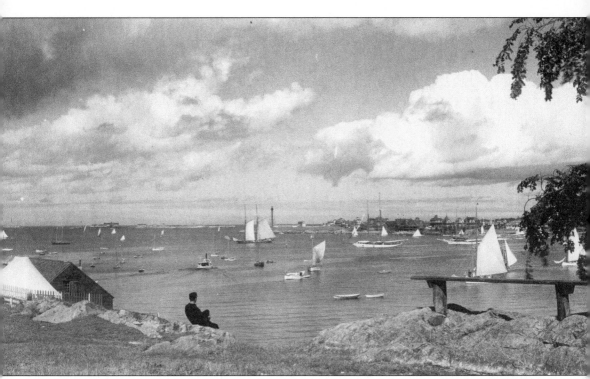

**THE HARBOR AND NECK FROM CROCKER PARK, C. 1905.** Wealthy businessman Uriel Crocker donated land (formerly called Bartoll's Head) to the Town of Marblehead in 1886, and it has since remained a park with an incomparable vista. From its rocky vantage point, this young man is surveying, among other sights, the hospital and related buildings on Children's Island, the distinctive 1896 light tower at Point o' Neck (later named Chandler Hovey Park), and the impressive homes interspersed between the two popular yacht clubs. The town's ace photographer, Fred B. Litchman, captured this idyllic scene one cloud-filled afternoon after he left his State Street studio. (Courtesy Marblehead Historical Society.)

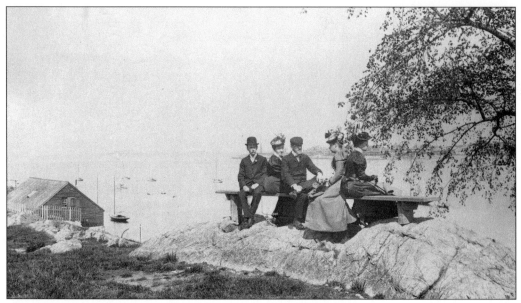

**"BOOKENDS" AND FRIENDS AT CROCKER PARK, C. 1900.** Fred B. Litchman and his future bride, Coralie Mason, flank the light tower on the Neck, while perched with contemporaries on a rustic bench. The Marblehead Transportation Building is at the left. (Courtesy Chadwick Collection.)

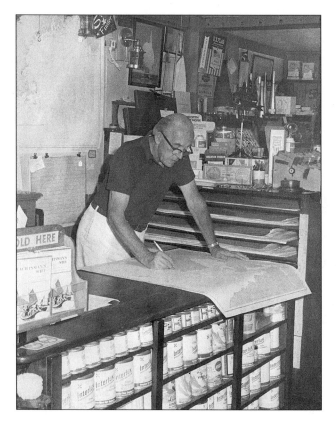

**FRED L. WOODS CHECKS A CHART IN HIS SHOP, 76 WASHINGTON STREET, C. 1948.** Brookline-born, but Marblehead-raised, Fred Woods carried on the centuries-old tradition of a ship's chandler by stocking nautical instruments, paint, and assorted marine supplies in his shop near the old town house. In 1939, he became the first government-appointed chart agent in Marblehead. His wife, the former Nathalie Frost, later became the first lady chart agent. (Courtesy Todd Waller.)

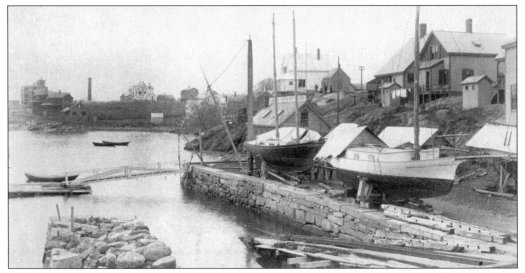

BILLOW'S BOATYARD, HATHAWAY'S WHARF, OFF LEE STREET, C. 1900. James Billows, a yacht and boat builder, repaired vessels during the summer season (when necessary) and "wintered them over," as shown here, near his shop. He supplied "yacht and boat trimmings and fittings of all descriptions," and he had "white ash oars always on hand." The brick tower of the 1894 electric generating plant is visible at the end of Commercial Street. Four men and boys are next to the ten-footer (a 19th-century term for a small shoemaking shop) on the rocky ledge. Two similarly shaped outhouses are perched nearby. (Courtesy Marblehead Historical Society.)

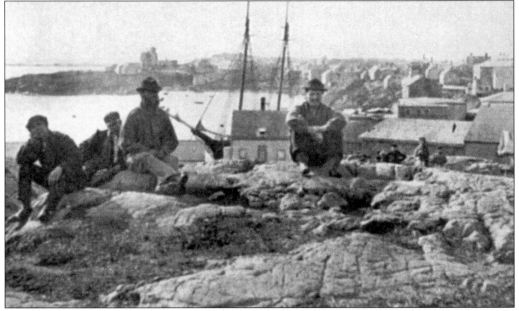

BARTOLL'S HEAD, C. 1870 STEREO VIEW. Marblehead menfolk find questionably comfortable seating on the steep, rocky promontory off Front Street. A partially visible two-masted silhouetted schooner adds to the scene's picturesque quality. This area was one of many in town where wooden fish flakes were set up to dry the odoriferous catch in the air and sun. In 1837, there were 55 local vessels and 550 men and boys fishing for cod and mackerel, the tonnage of which was 4,603. (Courtesy Marblehead Historical Society.)

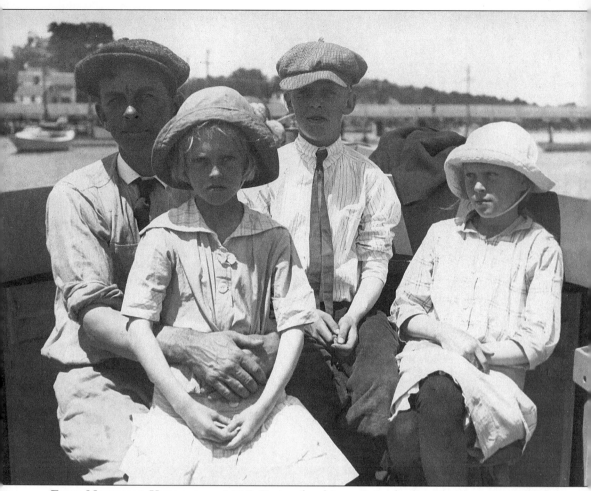

**Four Nautical Knights, c. 1915.** Posing for this engaging harborside picture on a bright, sunny day are, from left to right, Archie Selman Knight and his children—Alice Selman Knight, Russell Wallace Knight, and Ruth Elizabeth Knight. Russell Knight (1903–1994) became an astute businessman, a lifelong collector of Marbleheadiana, an author on aspects of the town's history, and a generous benefactor to local historical organizations. Like many boys his age who were members of local "gangs," Russell pitched rocks at other gang members, and sported a few youthful scars. (Photograph by Willard B. Jackson; courtesy Knight Collection.)

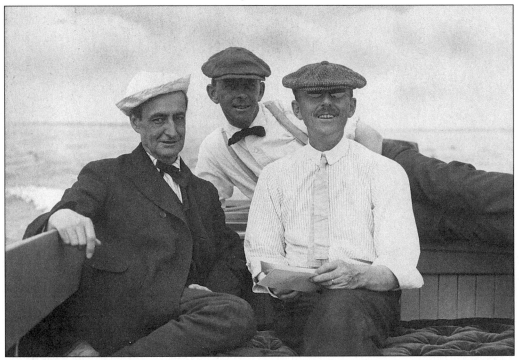

**THREE SAILING FRIENDS, C. 1920.** These convivial gents and friends of the photographer (he gave them each a print) enjoy a sail on his powerboat, the *Alison*. Shown, from left to right, are Frank Ramsdell, a printer; Archie S. Knight, a railroad worker; and their chum, George Bales. (Photograph by Willard B. Jackson; courtesy Knight Collection.)

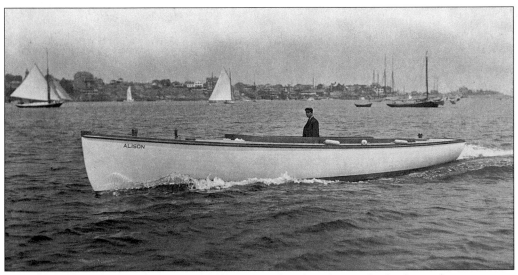

**A SOLO SAIL, C. 1915.** Archie S. Knight gathers his thoughts in the harbor as he maneuvers the photographer's powerboat, named for his daughter, Alison, who lived on Circle Street. Jackson also owned a fishing shanty near Fort Beach, where he and his cronies gathered to exchange news of the day and to reminisce. "Frostbiters" have sailed in the harbor on sunny winter days since 1947. (Photograph by Willard B. Jackson; courtesy Knight Collection.)

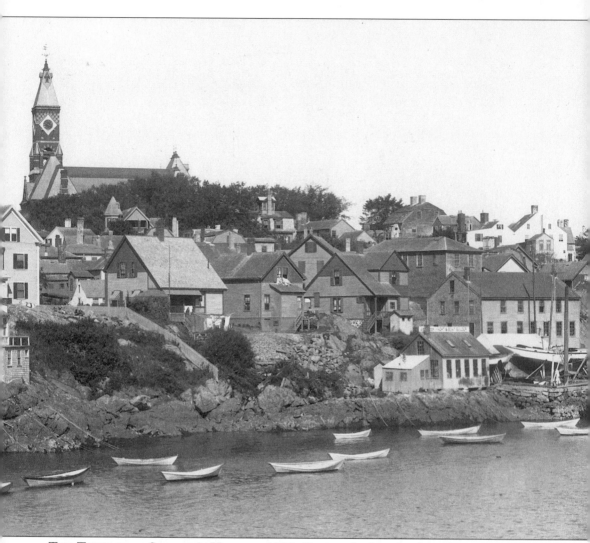

THE TOWN FROM SKINNER'S HEAD, C. 1900. Dories ride the tide along the seaweed-covered rocky shore, and roof shapes and chimneys bisect each other as one would expect when houses are built at strange angles in such a compact community. Eighteenth-century mansions owned by wealthy merchants often boasted a balustraded "widow's walk" on the flat roof, or had a cupola, such as the one on the 1768 Jeremiah Lee Mansion for the owner of vessels (or his presumed widow) to watch for their house flags among the many masts of arriving coastal schooners, merchant ships, and brigs. (Photograph by Willard B. Jackson; courtesy Woods Collection.)

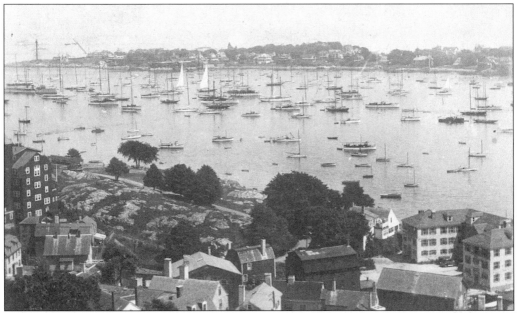

**A Harbor Panorama, c. 1910.** Previously located adjacent to Crocker Park (left) the New Fountain Inn (built in 1904–1905) was an ideal getaway for those patrons who wanted the best overall view of Marblehead Harbor. At water level, the U-shaped Boston Yacht Club (right) was known at this time as "the Ship's Cabin," and was a private hotel owned by yachtsman Charles H.W. Foster. He became a member of the Eastern Yacht Club in 1881, and authored its first history, *The Eastern Yacht Club Ditty Box, 1870–1900*, which was published in 1932. (Photograph by Fred B. Litchman; courtesy Maurais Collection.)

**The Ship's Cabin, 1 Front Street, c. 1935 Postcard.** A Palladian window is the focal point of the main entrance to the shingled building that became the new home of the Boston Yacht Club in 1956. On March 12 of that year, the Marblehead Harbor Yacht Club became part of the BYC. Twenty-five years earlier, while at the 75 Front Street location, there were approximately 350 members who paid an entrance fee of $30, and then $50 for each successive year's membership. (Courtesy Maurais Collection.)

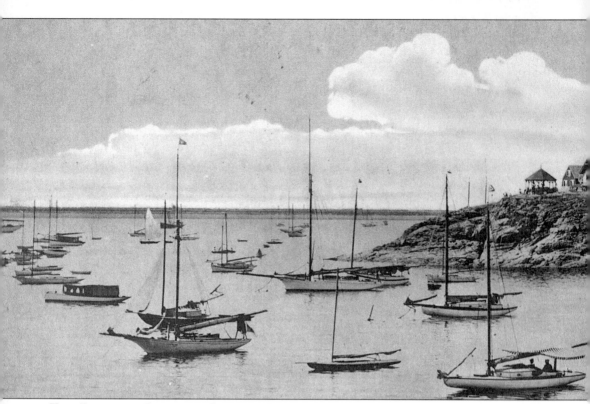

THE ROCKMERE INN FROM CROCKER PARK, 1906 POSTCARD MADE FROM A LITCHMAN PHOTOGRAPH. Ample-sized residences in the background are dwarfed by the sprawling wood-framed Rockmere Inn (also known as the Rock-Mere and the Rockmere Hotel). It was built in 1901, remodeled in 1905, and razed in 1965 for the Glover Landing complex. The octagonal

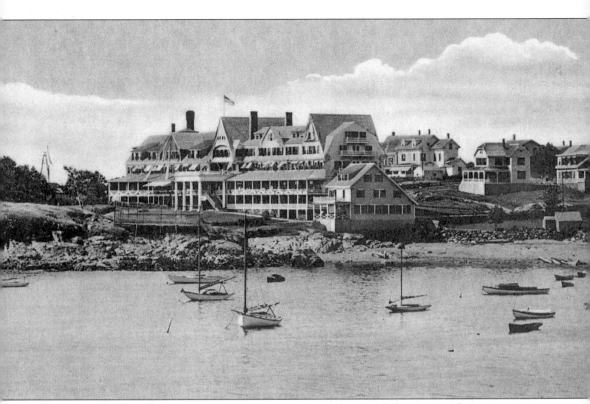

pavilion on the headland mimics the interesting roof shapes of the inn, with its two-story, classically inspired portico. A huge wrought-iron anchor weighing 13,625 tons and made for the U.S. Navy in 1900 stands on Gregory Street opposite Lindsey Street, where it once welcomed guests to the Rockmere Inn, and now identifies Glover Landing. (Courtesy Swift Collection.)

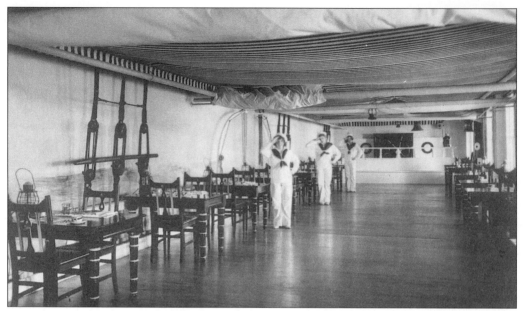

"At Your Service," Quarter Deck, SS Rock-Mere, Hotel Rock-Mere, c. 1930s Postcard. These nautically outfitted waitresses stand at attention and salute for the photographer, and probably for special guests who patronized the Quarter Deck. (Courtesy Maurias Collection.)

Second Cove, c. 1895. A man on the cliff surveys the cove located between Redstone Cove and Skinner's Head from a better vantage point than the man and boys by the lobster trap. The Second Empire house with a projecting porch was owned by the Parker and Allerton families during the 1880s and 1890s respectively. (Courtesy Goddard Collection.)

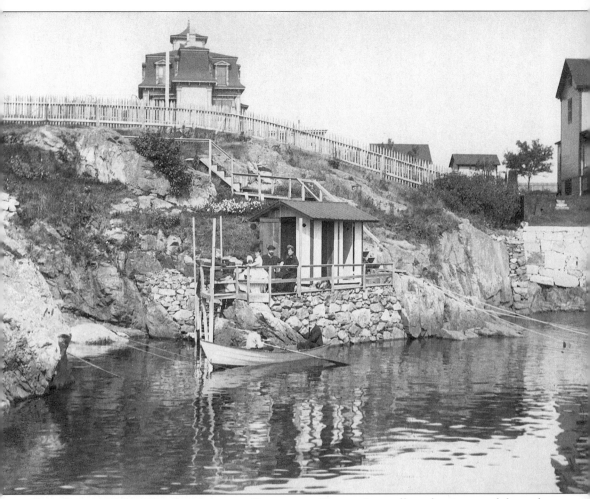

**The Parker Family's Boathouse, Redstone Cove.** A small and trim wood-framed structure enabled the Charles W. Parker family and their friends to enjoy the benefits of being near or on the water before they moved to the Neck in 1886. Mrs. Parker, Mary Parker, Florence W. Dyer, Alice Potter, Arthur H. Dyer, and Jim (the dog) probably all wish they could join the patriarch of the family and his son, Ross, for an excursion in the dory. (1882 photograph by Herman Parker; courtesy Parker Collection.)

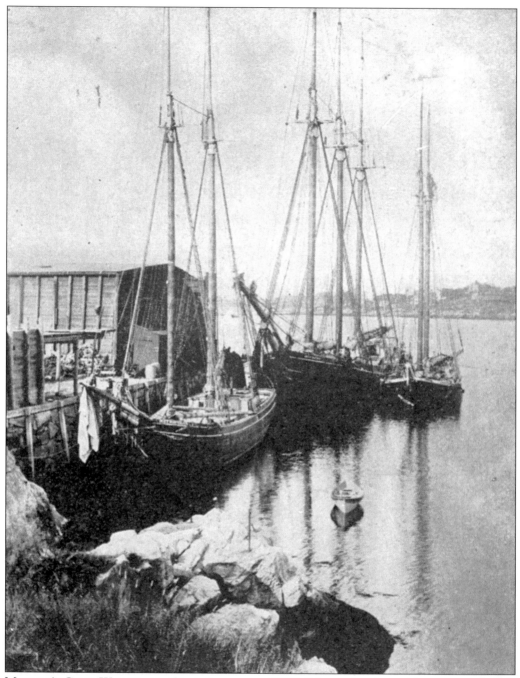

**MARTIN'S COAL WHARF, OFF CLIFF STREET, C. 1900.** The coal and wood business to the left of the schooners—the *Metropolis* (foreground), from Vinal Haven, Maine; the *Ida W. Mathis*, a coal carrier; and, the *Hume*, a lime and lumber carrier—was established by John S. Martin in 1886. Eight years later, Martin purchased the 1854 wharf from Otis Roberts, who had operated a large box factory there. Martin's coal sheds held tons of anthracite available in four sizes—pea, nut, stove, and egg—as well as wood shingles, roofing, and masonry supplies. (Photograph by Fred B. Litchman; courtesy Bull Collection.)

**THE MARBLEHEAD YACHT CLUB (MYC), 4 CLIFF STREET.** Founded in 1878, and still at the same location, the "working man's yacht club" is nestled in near the end of the harbor in the "Shipyard" neighborhood. Unlike the larger yacht clubs that provide many amenities for their socially prominent members who own larger vessels, the MYC is a basic services club. But it is one that does not lack spirit or camaraderie among volunteers who maintain the building and work on their own or their friends' sailboats or powerboats.

**THE DOLPHIN YACHT CLUB'S FLOAT, 17 ALLERTON PLACE.** Incorporated on March 30, 1951, by members of the Jewish faith, the Dolphin Yacht Club was established "to encourage and promote yachting and related water sports." The first commodore was Harry Weinstein (1951), and succeeding in that capacity every ten years were Arnold Massirman (1961); Dr. Ronald Goldberg (1971); Benjamin Miller (1981); and Elliot M. Strasnick (1991). Members who have won the Herring River Race between 1971 and 1977 have their names inscribed on the club's trophy.

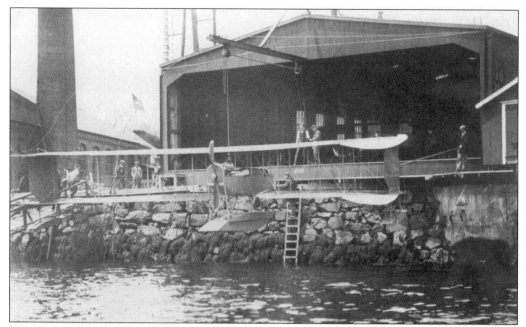

THE BURGESS AIRPLANE FACTORY, ELECTRIC LIGHT WHARF, C. 1915. Early aviation buffs came to Marblehead to work with W. Starling Burgess at factory No. 1, located at the end of Redstone Lane adjacent to the electric generating plant, the brick tower of which is at the left. Many Burgess-built planes were sold to the U.S. Army and Navy for use in WWI. After merging with Curtiss Aeroplane, Burgess left Marblehead for Washington, D.C., where he supervised the construction of planes for wartime use. This factory was destroyed by fire around 1918. (Courtesy North Shore Jewish Historical Society.)

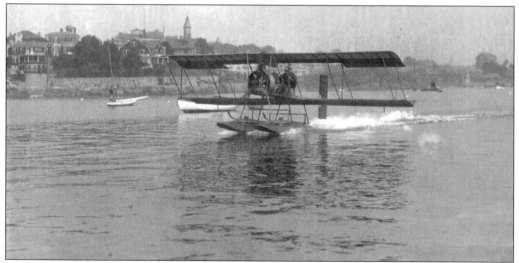

THE "FLYING FISH," C. 1915. Seven years after the Wright brothers' 1910 flight at Kitty Hawk, North Carolina, W. Starling Burgess's aptly named biplane took to the air locally. A bronze plaque on the first floor of Abbot Hall gives credit to the town for being the birthplace of Marine Corps aviation: "Near this spot on 20 August 1912, First Lieutenant Alfred A. Cunningham, the U.S. Marine Corps' first aviator, made his first solo flight at the Burgess-Curtiss Airplane factory, Red Stone Lane, Marblehead, Massachusetts." (Courtesy Chadwick Collection.)

48

**PADDLING BY HARBOR VIEW, 1935.** Carol and Jim Apthorp pause for a snapshot in the deceptively low boat that their inventor-father, Robert E. Apthorp, designed and named a "platter boat." The Apthorp family wintered in Milton, Massachusetts, and summered at what was then 4 Harbor View, off Chestnut Street. (Courtesy Edith B. Abbot.)

**A SISTERLY INTERPRETATION, 1934.** Madeline "Muddle" and Edith "Budge" Abbot, the youngest and older daughter of Mr. and Mrs. W. Lyle Abbot, look at a picture book on "Firecracker Rocks" near their summer home at what was then 6 Harbor View. *Ace,* the boat that their father had named for his first three daughters, was later renamed *Acme* when Madeline was born. (Courtesy Abbot Collection.)

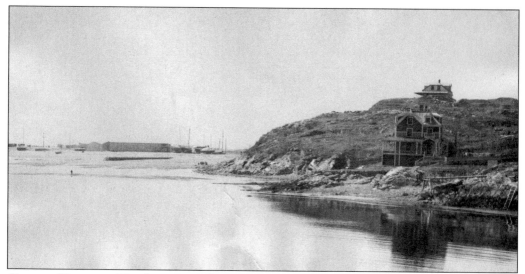

**GILBERT HEIGHTS.** The flat area at the top of Gilbert Heights off Ocean Avenue was named Cow Fort before the 103-day Spanish-American War in 1898, when it was revamped and called Fort Glover. Boat sheds and beached vessels are along Riverhead Beach near the beginning of the Causeway. (Early-20th-century photograph.)

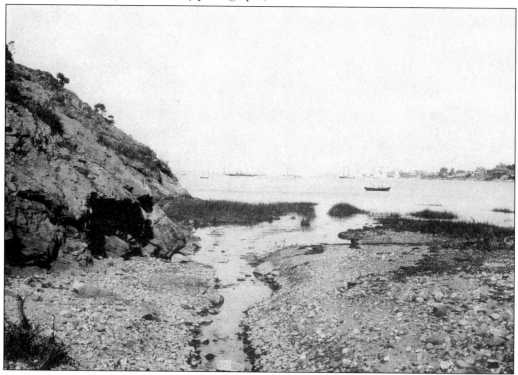

**MARBLEHEAD HARBOR FROM RIVERHEAD BEACH.** The natural breakdown of rocks along the water's edge of the town has left the beaches with a hard-to-walk-on surface, as seen here and across the Causeway at Devereux Beach. The underground drainage in the photograph is from the Goldthwait Reservation, an area that had been used centuries beforehand by Native Americans. (1891 photograph by Herman Parker; courtesy Parker Collection.)

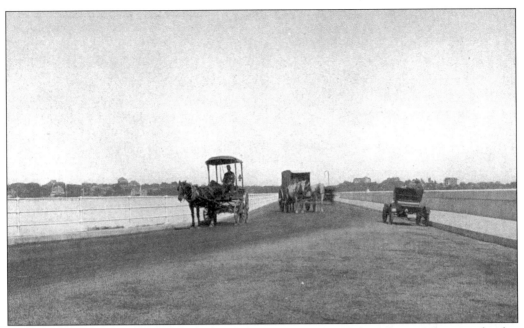

THE CAUSEWAY, C. 1908. Horse-drawn carriages compete with horseless carriages on the dirt road of the curved Causeway. The see-through iron fence on the harbor side gave travelers a better view than the concrete seawall on the Atlantic Ocean side of the connecting roadway, which was built around 1870. (Courtesy Swift Collection.)

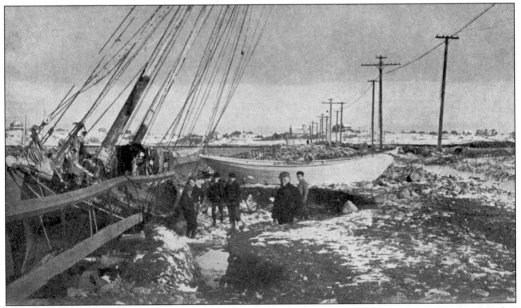

THE CAUSEWAY AFTER A STORM, C. 1899. A devastating storm known as the "Portland Gale" wreaked havoc in Marblehead Harbor as it did along other New England seacoast areas on November 27, 1898. The worst nor'easter since that of 1851, its winds were clocked at between 60 and 70 mph, causing damage to vessels such as the *Eddie A. Minott*. The schooner has crashed into the wooden fence on the Causeway, and a sizable dory lies upright, perpendicular to the road; the concrete seawall has been reduced to rubble. (Courtesy Swift Collection.)

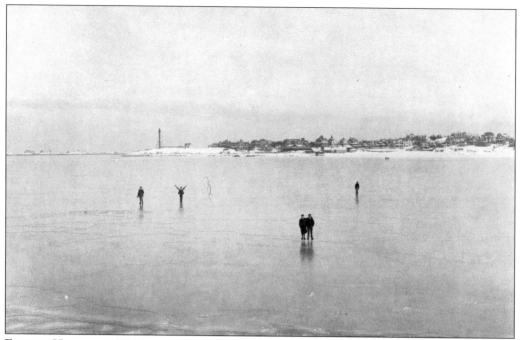

**FROZEN HARBOR, 1904 POSTCARD.** Many harbor freezes have occurred in the past, and this one provided the opportunity for those with derring-do to walk between Fort Sewall and Point o' Rocks (also called Point o' Neck) and live to tell the story. (Courtesy Swift Collection.)

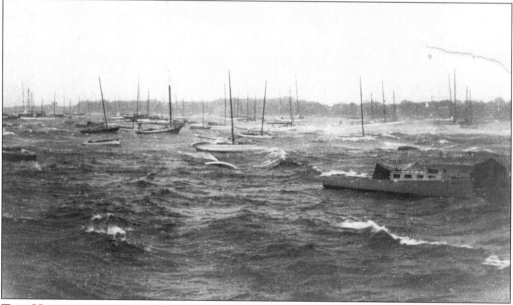

**THE HURRICANE OF 1938 SURPRISES MARBLEHEAD HARBOR, SEPTEMBER 21.** Sailboats, luxury yachts, and other craft try to ride out the 90-mph dry southeast "windstorm" that capsized or destroyed them on that fateful afternoon. Although losses were estimated to be in the millions of dollars, and many vessel owners and crew members were hurt, fortunately no lives were lost during the disaster. This photograph was taken from the old Boston Yacht Club at the foot of State Street. (Courtesy Bull Collection.)

**A Collectible Souvenir, c. 1895 Postcard.** With raised, polychromed, and often gilded highlights, turn-of-the-century fanciful postcards were specifically printed with the name of a popular town or city. They appealed to tourists who probably did not care or know that the scenes depicted were generic. (Courtesy Maurais Collection.)

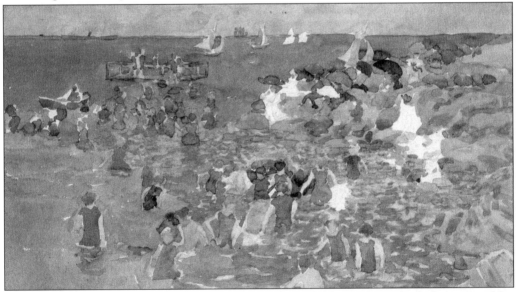

**Bathing, Marblehead.** Maurice Brazil Prendergast, a lifelong artistic bachelor, painted his most enduring impressionist scenes of young women and girls at play in amusement parks, picnic spots, carnivals, and beaches—the subject of this 14- by 20-inch composition. During the summers of 1896 and 1897, Prendergast frequented the beaches of Marblehead, Nahant, and Revere. (*Circa* 1896–1897 watercolor and pencil on paper by Maurice Brazil Prendergast, 1859–1924; courtesy Museum of Fine Arts, Boston; given in memory of Mr. and Mrs. John Howard Nichols by their daughter, Charlotte Nichols Greene.)

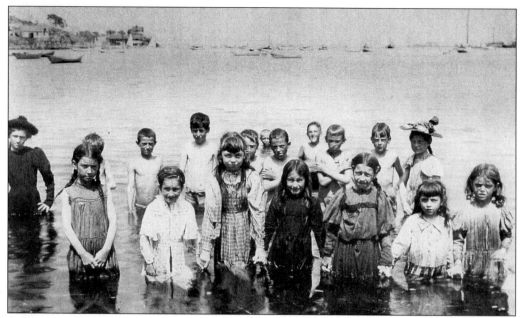

**A DAY AT THE BEACH, C. 1900.** Standing alone, or with their hands clasped together or across their chests, these children really are enjoying wading in the cold water, although most of their expressions tell a different story. (Courtesy Marblehead Historical Society.)

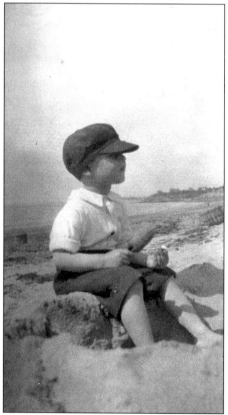

**A BEACH BOY, C. 1926.** With trowel in hand, Paul Neily, the son of Mr. and Mrs. Alvah Beaumont Neily, who resided on Stony Brook Road, enjoys a carefree day at Devereux Beach. (Courtesy Ellen Neily Antiques.)

**DEVEREUX BEACH, C. 1930 POSTCARD.** Native Americans had previously camped in this area, owned by 17th-century settler John Devereux. As early as 1729, an act was passed by the town selectmen for "securing and repairing the harbor, and to prohibit persons carrying off sand, seaweed, etc., from the beach." By 1906, the town had acquired the land, flats, and beach, which had been dotted by some randomly built shacks. Popular Devereux Beach is located on the Atlantic Ocean side of the Causeway. (Courtesy Maurais Collection.)

**CLIFTON HEIGHTS.** A large, pointed, gambrel-roofed and shingled house with a wraparound piazza on a promontory next to a smaller dwelling with a jerkin-head roof stand in proximity to their Carpenter Gothic neighbors along the shore near Swampscott, which was incorporated in 1852. (Early-20th-century photograph; courtesy Chadwick Collection.)

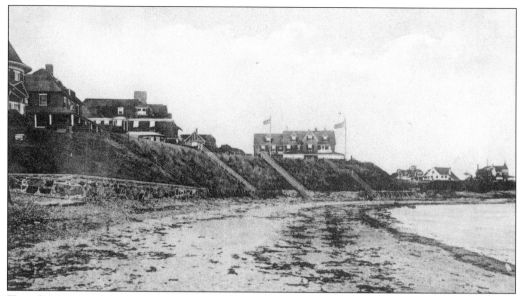

THE CLIFTON SHORE, C. 1910 POSTCARD. In 1884, many residents of Clifton, the Neck, and Devereux unsuccessfully petitioned the state legislature to secede from Marblehead because they felt the taxes they paid were not equal to the services provided by the town. (Courtesy Maurais Collection.)

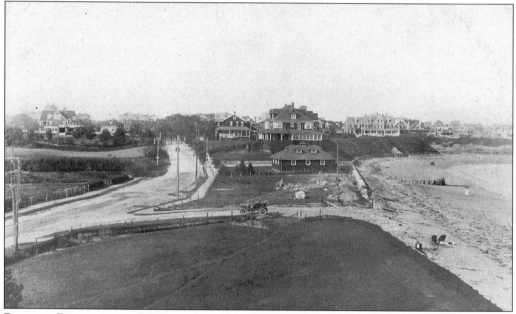

PRESTON BEACH BY THE MARBLEHEAD-SWAMPSCOTT TOWN LINES, C. 1910 POSTCARD. The Z-shaped configuration of the dirt roads in this wealthy residential area shows Seaview Avenue as it intersects with Atlantic Avenue, and the dirt road that leads to the beach with its scenic vista. Atlantic Avenue, Humphrey Street, Tedesco Street, and Lafayette Street (Route 114) are the main access roads to and from Marblehead. (Courtesy Maurais Collection.)

# Two
# VALOROUS NAVAL
# EXPLOITS

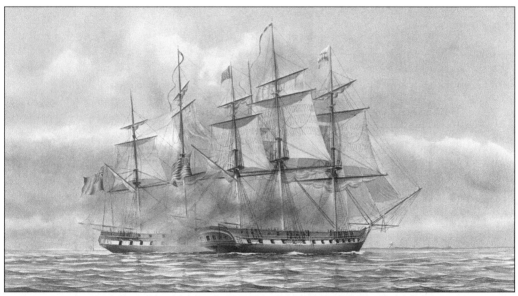

**ENGAGEMENT OF U.S. FRIGATE CHESAPEAKE AND HMS SHANNON OFF MARBLEHEAD, JUNE 1, 1813.** One of the most famous exclamations in American naval history, "Don't give up the ship!," was uttered by mortally wounded Capt. James Lawrence, commander of the *Chesapeake* (49 guns), after it was defeated by the British frigate *Shannon* (52 guns) off Marblehead Neck. During the late 18th and early 19th centuries, Marbleheaders and vessels associated one way or another with the town, provided invaluable assistance to the American cause in both the Revolutionary War and the War of 1812. Local heroes include Gen. John Glover, and Captains Nicholson Broughton, John Manley, James Mugford, and Samuel Tucker. (*Circa* 1940 poster of watercolor by John F. Leavitt; courtesy National Grand Bank of Marblehead.)

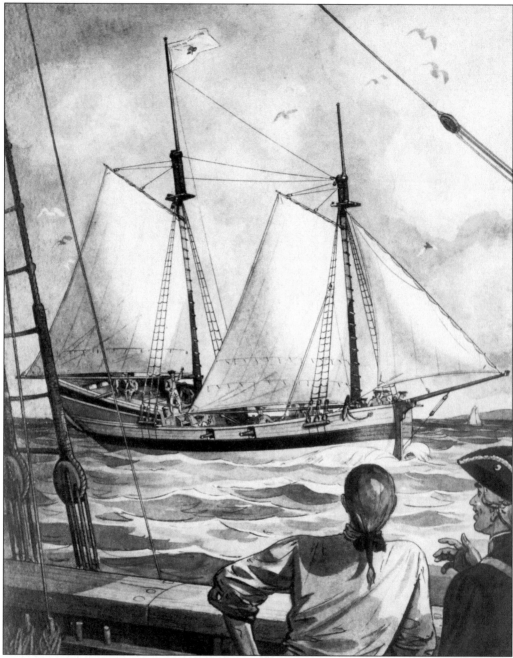

**THE HANNAH.** Seamen from another converted fishing-to-schooner warship admire the two-masted *Hannah*, the first American warship to be commissioned (on September 2, 1775) by Gen. George Washington. He ordered the ship "to proceed immediately against vessels . . . bound inwards and outwards to or from Boston in the service of the Ministerial Army . . . and to seize all such vessels." Although *Hannah*'s naval career was "brief, unsuccessful, and troublesome," she was rebuilt and renamed *Lynch* the following year. Its claim to fame is that it was the first vessel of the fledgling Continental Navy. (*Circa* 1930 illustration by an unidentified artist; courtesy Chadwick Collection.)

**EMBRYO OF THE AMERICAN NAVY.** Two British warships flank the sail-shot schooner *Hannah* "running the gauntlet" off Cape Ann (Gloucester area) on September 5, 1775. Friendly rivalry has existed for many decades between Marbleheaders and Beverlyites over which community's claim to be the "Birthplace of the American Navy" is historically correct. Named for Col. John Glover's wife, Hannah Gale Glover, the Marblehead fishing schooner was converted to a warship at Glover's Wharf in Beverly, from where it sailed with Capt. Nicholson Broughton and his crew of seamen, most of whom were 'Headers. (Mid-19th-century engraving; courtesy Swasey Collection.)

**DAVID QUILL.** One of several Marblehead men who manned the *Constitution* during the War of 1812, David Quill served as the ship's quartermaster. Civilian Quill wore a gold pin with the first initial of his surname when he sat for his portrait by 17-year-old William T. Bartoll. This strong likeness of the gentleman with reddish side whiskers is the artist's earliest signed and dated portrait. (1829 oil painting on canvas by William T. Bartoll, 1812–1859; courtesy Marblehead Historical Society.)

**OLD IRONSIDES ENTERING MARBLEHEAD HARBOR, APRIL 3, 1814.** America's greatest warship, the USS *Constitution*, was safely guided into the town's protective harbor for the first time by local fisherman-sailor Samuel Harris Green in order to avoid capture by two British frigates, HMS *Tenedos* and HMS *Endymion*, while becalmed on the North Shore of Massachusetts Bay. The powderless cannons at Fort Sewall intimidated the British warships to the delight of the jubilant inhabitants, who had no idea that the *Constitution* would later become a famous icon of America's naval history. (*Circa* 1970 poster of watercolor by John F. Leavitt; courtesy National Grand Bank of Marblehead.)

**"Old Ironsides" Visits Marblehead Harbor, July 29, 1931.** One hundred seventeen years later, Marbleheaders were again delighted when the *Constitution* dropped anchor in the harbor while on a thank-you tour for its restoration. At that time, the tugboat *Iwana*, the yacht *Grebe*, and at least one Navy launch escorted and encircled the majestic vessel as people watched from sea and shore. (Photograph by Willard B. Jackson; courtesy Bull Collection.)

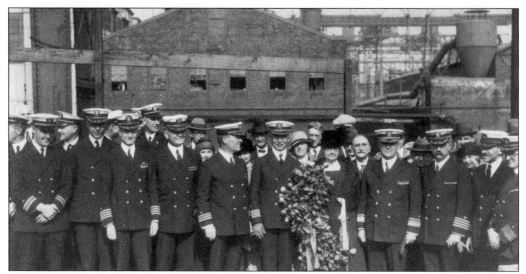

**AT THE CHRISTENING OF THE USS MARBLEHEAD, OCTOBER 9, 1923.** On hand to celebrate the launching of the light cruiser *Marblehead* (the third American naval vessel to be so named) at Philadelphia, Pennsylvania, were some of the town's selectmen and Mr. and Mrs. Joseph Herbert Evans, who resided on Maverick Street. Hannah Martin Graves Evans was selected as sponsor of the warship—she was the town's first Gold Star Mother; her son, 2d Lt. Charles H. Evans, was the first local soldier killed in WWI. Hannah Evans christened the cruiser with a bottle containing water from Marblehead Harbor. (Courtesy Donald A. Doliber Sr.)

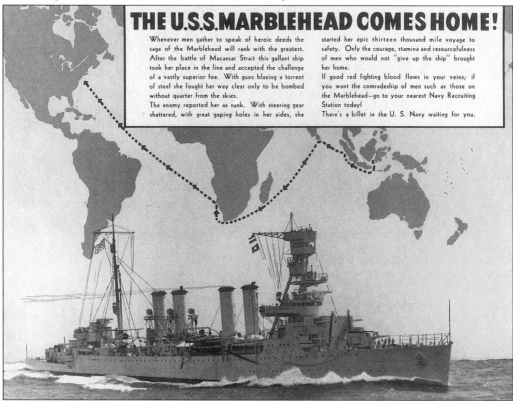

# THE U.S.S. MARBLEHEAD COMES HOME!

Whenever men gather to speak of heroic deeds the saga of the Marblehead will rank with the greatest. After the battle of Macassar Strait this gallant ship took her place in the line and accepted the challenge of a vastly superior foe. With guns blazing a torrent of steel she fought her way clear only to be bombed without quarter from the skies.

The enemy reported her as sunk. With steering gear shattered, with great gaping holes in her sides, she started her epic thirteen thousand mile voyage to safety. Only the courage, stamina and resourcefulness of men who would not "give up the ship" brought her home.

If good red fighting blood flows in your veins; if you want the comradeship of men such as those on the Marblehead—go to your nearest Navy Recruiting Station today!

There's a billet in the U. S. Navy waiting for you.

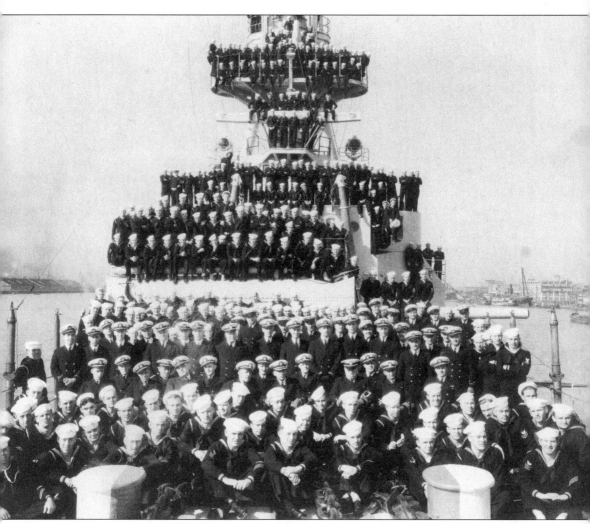

**CREW MEMBERS OF THE USS MARBLEHEAD, JULY 29, 1937.** Spruced-up sailors and their commanding officers pose in pyramidal fashion for this commemorative picture taken in Shanghai Harbor. Ens. Frederic W. Kinsley of Marblehead is in the front row of standing officers, twelfth from the left. The 22- by 22-inch bronze bell from the warship is on permanent display in Abbot Hall. An accompanying label states that it was "presented to the Town of Marblehead as a memento of a battling ship and its fighting men, in the battle of the Java Sea, Feb. 4, 1942." (Courtesy Ret. Cdr. Frederic W. Kinsley.)

**OPPOSITE, BOTTOM: "THE USS MARBLEHEAD COMES HOME!"** After enduring a severe raid by 36 Japanese twin-engine bombers on February 4, 1942, while stationed in the Far East, the light cruiser USS *Marblehead* miraculously stayed afloat against insurmountable odds. The vessel somehow made it to Tjilatjap on the south coast of Java, where it was patched up for the long voyage back to America (see arrow trail above). Modernization at the Brooklyn Navy Yard in 1942 enabled it later to escort North Atlantic convoy ships and aid in the Allies' invasion of France. The gallant vessel was decommissioned on November 1, 1945, but the memory of its service and brave crew members live on in the annals of American naval history. (*Circa* 1944 poster; courtesy Goddard Collection.)

GOODWIN'S POINT. Marblehead-born primitive artist John Orne Johnson Frost, known in American Folk Art histories and auction catalogs as "J.O.J. Frost," often incorporated historical quotations and local lore into the fanciful paintings he created to commemorate events of importance to the town he loved so much. In this "house paint" picture, the artist makes reference to the British troops from the transport *Lively* who, on a cold Sunday morning in February 1775, landed in town with fixed bayonets so they could march to Salem to confiscate cannon and ammunition stored beyond what became known as the country's "first" North Bridge. (Detail of *c.* 1920s painting on masonite by J.O.J. Frost, 1852–1928; courtesy Marblehead Historical Society.)

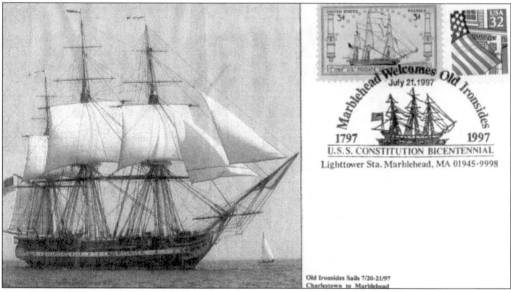

STAMPED COMMEMORATIVE ENVELOPE, JULY 21, 1997. The *Constitution's* much anticipated third and carefully planned visit to the town was a two-day historic celebration on July 20 and 21, 1997. On the second day, six newly fabricated synthetic sails (part of the $12,000,000 restoration cost) enabled the gallant warship to sail untethered for one hour between Marblehead and Nahant for the first time in over 116 years. Twenty-one-gun cannon salutes and Delta formation flights by the famed Blue Angels added to the spectacle of seeing the *Constitution* in a different setting than at her berth at the Charlestown Navy Yard. (Courtesy Swift Collection.)

# *Three*

# THE GREAT NECK

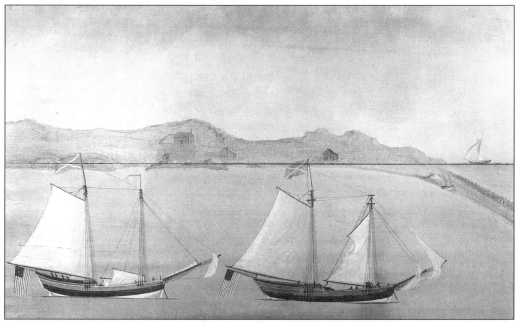

**CAPT. NICHOLAS BARTLETT'S SCHOONERS WITH MARBLEHEAD NECK IN THE BACKGROUND.** As early as 1614, Capt. John Smith of Plymouth, Massachusetts, explored the Marblehead coastline and spent a few refreshing days on the Great Neck, which he referred to as "Manataug" for its Naumkeag Indian name. By the first decade of the 19th century, when this scene was painted, there were still only a few modest houses on the Neck, and most of the inhabitants were involved in drying fish or haying. During the third quarter of the same century, residents from Lowell, Massachusetts, and Nashua, New Hampshire, set up summer camps (as did some Salemites) on the Neck's salubrious shoreline. The sale of land to these campers and others who wanted to build summer homes there followed the construction of the Causeway. Yachting's pleasure and sport drew wealthy and socially prominent individuals and their families to Marblehead Neck, where they established nationally known yacht clubs before 1900. (*Circa* 1805 fireboard painted by an unidentified artist; courtesy Marblehead Historical Society.)

**A VIEW OF MARBLEHEAD NECK.** This late-18th-century depiction of the Neck—which was still either an isthmus or island depending on the vagaries of successive storms—shows the three-masted vessel that Capt. Stiness sailed into Marblehead Harbor in a "race" (in which he won first-place) with his uncle, Capt. Philip Bessom. (*Circa* 1797 fireboard attributed to Capt. Samuel Stiness; courtesy Knight Collection.)

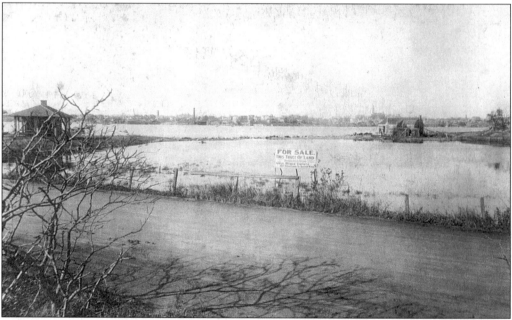

**LAND FOR SALE ON HARBOR AVENUE.** On January 11, 1872, the land (approximately 230 acres) belonging to the estate of Ephraim Brown was sold at auction for $255,000 to the Marblehead Great Neck Land Company, making it the first major real estate transaction on the Neck. William J. Goldthwait and Gardner R. Hathaway were real estate brokers in town at the turn of the century, but the Boston Wyman Estate firm probably sold this flooded property near the intersection of Foster Street and Harbor Avenue. (Early-20th-century photograph by Fred B. Litchman; courtesy Marblehead Historical Society.)

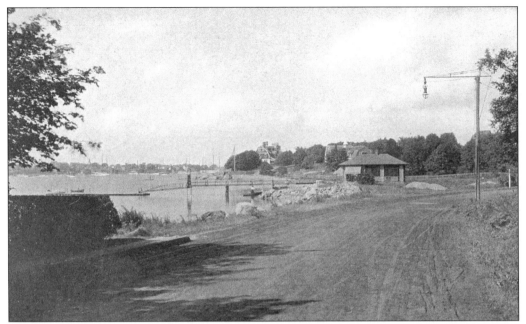

"A PRIVATE LANDING," NEAR THE BEGINNING OF HARBOR AVENUE, C. 1900. The pavilion, ramp, and float were built for Robert C. Bridge who, with his family, resided nearby in Yerxa Cottage. Redgate, one of the most impressive mansions on the Neck, is at the left. Electricity was installed in the town in January of 1895, and the current reached the Neck shortly thereafter. (Courtesy Swift Collection.)

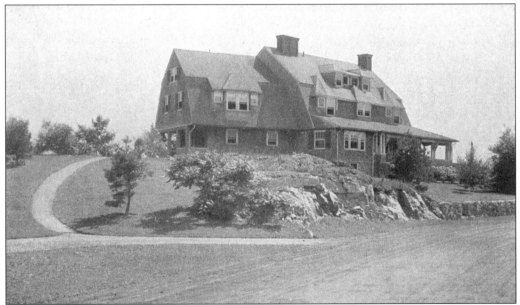

YERXA COTTAGE, CORNER OF HARBOR AND OCEAN AVENUES, C. 1900. This gambrel-roofed, shingle-style dwelling with its clustered dormer windows was built before the turn of the century. It is the first house encountered at the end of the Causeway. Robert C. Bridge, the entrepreneur who built the Nanepashemet Hotel (see p. 88), was a former owner. (Courtesy Swift Collection.)

PARKHILL LODGE, BETWEEN BROWN STREET AND WALLINGFORD ROAD, C. 1900. Owned by the Parker family, Parkhill Lodge was sited to have a spectacular view of the harbor and town. (Courtesy Swift Collection.)

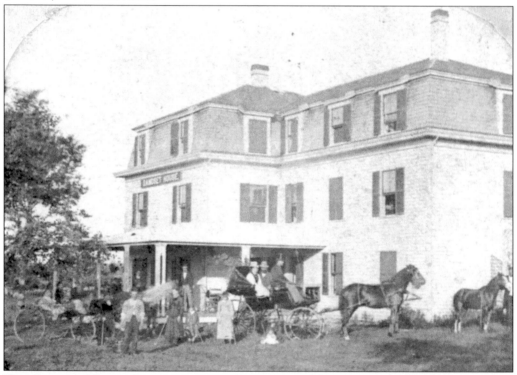

THE SAMOSET HOUSE, INTERSECTION OF FOSTER AND NANEPASHEMET STREETS. A section of the popular hotel is thought to have been constructed in the 1760s by wealthy shoreman John Andrews. However, the clapboard-framed building as shown was built in the French Empire style during the third quarter of the 19th century. The Eastern Yacht Club later acquired it for use as employee housing and guest rooms until the early 1970s, when it was razed. (1870s stereo view; private collection.)

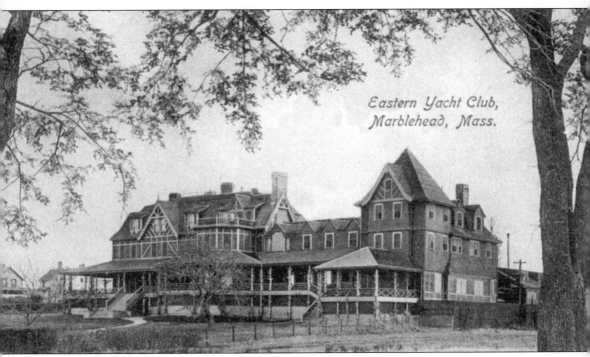

*Eastern Yacht Club, Marblehead, Mass.*

**THE EASTERN YACHT CLUB, FOSTER STREET.** The 1902 addition to the right side of the clubhouse provided 17 new rooms, a billiard parlor, a private dining room and kitchen, and a reading room for members and their guests. In 1931, during the "Golden Age of Yachting," William T. Aldrich was the club's commodore, and Chandler Hovey served as vice commodore of the approximately 350-boat fleet. The entrance fee was $85 that year, and the amount for annual dues remained the same. The annual regattas for the *Puritan* and *Cleopatra's Barge* cups were the best-known yachting events then held in New England. Junior yachtsmen competed for the Sears Cup, and the Norman Cup was awarded to the fastest schooner in the race from Bar Harbor, Maine, to Marblehead. (*Circa* 1915 postcard; courtesy McGrath Collection.)

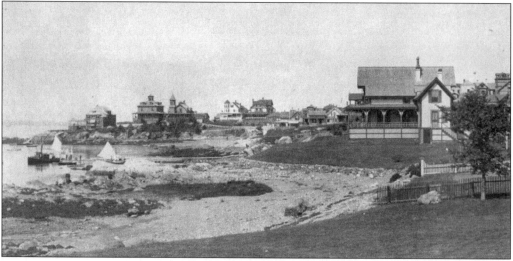

VICTORIAN HOUSES ALONG THE SHORE, C. 1900. The architects of these late-19th-century "cottages" between the Eastern and Corinthian Yacht Clubs designed compatible residences for their wealthy clients, many of whom lived in Boston during the seasons other than summer. (Courtesy Marblehead Historical Society.)

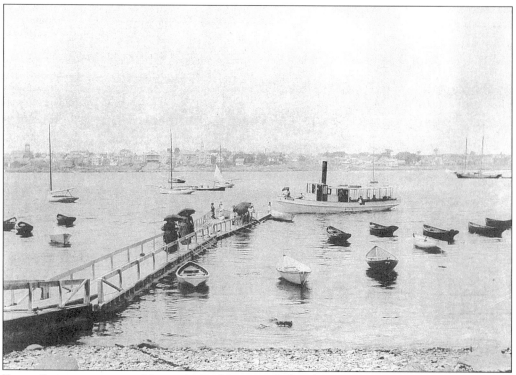

FERRY LANDING ON THE NECK, 1892. Victorian ladies dressed in black with complementary parasols walk on the ramp to the steam-powered ferry *Blonde*, which will transport them to the mainland. The *Lizzie May* began ferry service to the Neck as early as 1880. (Photograph by Herman Parker; courtesy Parker Collection.)

**SNOW'S VARIETY STORE AND POST OFFICE, 103 HARBOR AVENUE, C. 1900 POSTCARD.** The store that Thomas Snow and his family operated at this address for about 21 years sold the items advertised on their permanent and temporary signs, and it was the drop-off and pick-up location for the well-known Lewando's dry cleaning establishment in Boston. Merrill H. Graves, who operated a book and stationary store on the mainland, was the summer postmaster in the 1880s. Free postal delivery was begun on the Neck in October 1901. (Courtesy Swift Collection.)

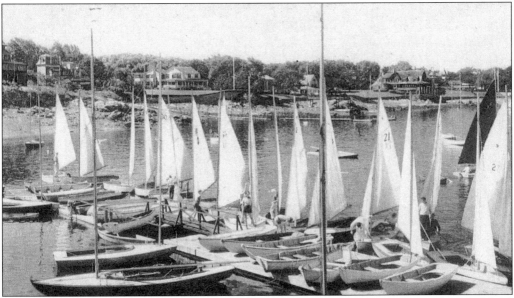

**THE PLEON YACHT CLUB'S WHARF, 42 FOSTER STREET, 1950S POSTCARD.** Arthur Goodwin Wood was the first commodore of the yacht club founded in 1887 by boys who were interested in sportsmanship and who sailed small boats. The red and blue burgee (an identification or signaling pennant) with a white star is associated with those youthful members under the age of 21 who have enjoyed the club's social interaction since its headquarters was built adjacent to the Old Stone Pier ferry landing. The word *sailing* is the translation of the Greek word *pleon*. (Courtesy Swift Collection.)

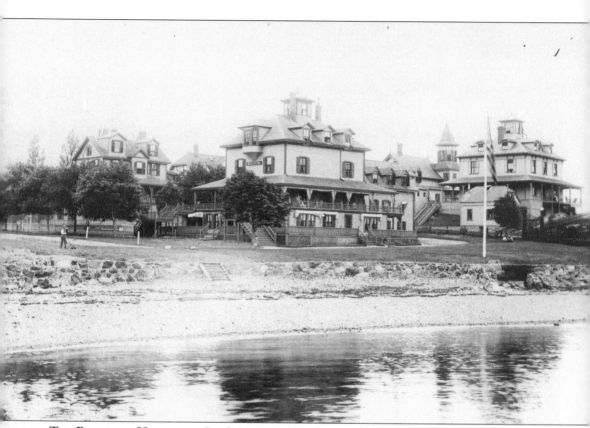

**THE BOYLSTON HOUSE AND ITS SURROUNDINGS.** Formerly located between Nahant Street and Corinthian Lane, the Boylston hostelry and its four architectural neighbors gave the effect of a compound. In 1902, when M.P. Dunlop was the proprietor of the Dunlop House, it and the adjacent Irving Cottages were described in a local advertisement as being "near the start and finish line of the many yacht races which occur throughout the summer . . . . The rooms are large, with spacious verandas surrounding the house and well-kept lawns and tennis courts." Ironically, after the buildings in the area were razed, the tennis courts of the Corinthian Yacht Club were built there. (*Circa* 1900 photograph by Willard B. Jackson; courtesy McGrath Collection.)

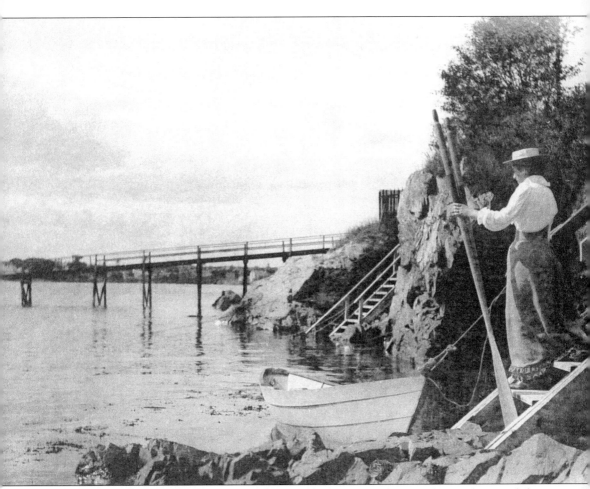

**"HER MORNING ROW."** With oars in hand, a young woman who may be a relative of the photographer poses before gracefully negotiating the dory in her long, ruffled skirt. The equally long ramp at Corinthian Point is in the background. (1892 photograph by Herman Parker; courtesy Parker Collection.)

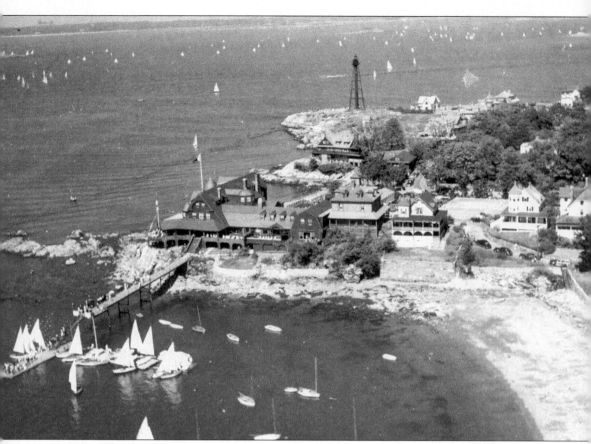

**THE CORINTHIAN YACHT CLUB (CYC) FROM THE AIR.** Sparhawk Point, near the end of the Neck on the inner harbor side, became the new headquarters of Marblehead's second yacht club in 1887, opening its doors to members on July 14 of the following year. In 1931, George E. McQuesten was the commodore of the CYC, which led New England in small boat racing, and Richard Boardman was the vice commodore; early officers of the club were elected the second Wednesday in January at Boston. The entrance fee and annual dues in 1931 were $60 for use of the spacious quarters. During the previous year, 2,000 boats were involved in 15 weeks of racing during the summer season. (1940s photograph by Bob Crowell; courtesy McGrath Collection.)

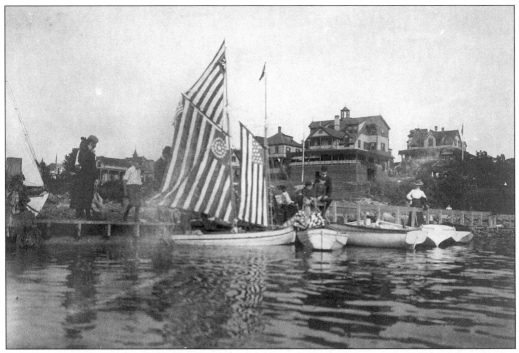

**OFF TO THE YACHT, C. 1900.** Pegasus, the Greek mythological horse, is the Corinthian Yacht Club's logo; it is accompanied with the Latin motto, "*Et Certare Pares Et Respondere Parati,*" which means, "All is ready to contend and prepared to answer back." (Courtesy Chadwick Collection.)

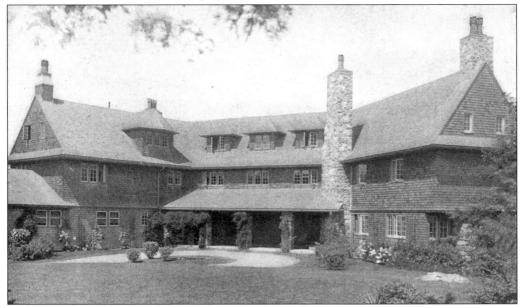

**GREY COURT, 15 KIMBALL STREET, C. 1900.** David C. Percival's spacious shingle-style house overlooks the harbor from the rear elevation, near the Corinthian Yacht Club. Two gabled wings with sloping roofs flank the main entrance, with its columned-supported wide roof. The impressive structure was later remodeled and made smaller by the removal of the third story. (Courtesy Swift Collection.)

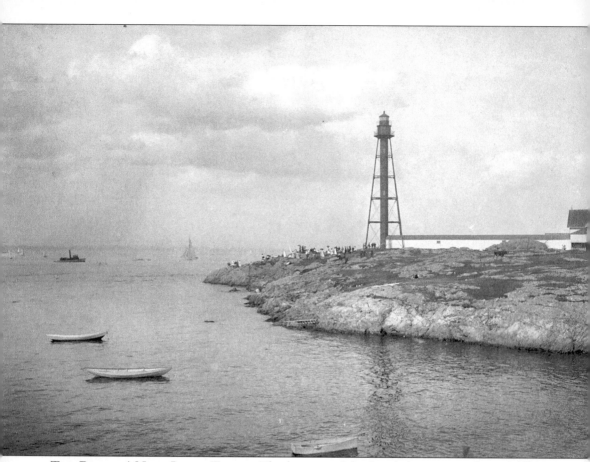

THE POINT O' NECK LIGHT TOWER. The lowness of the first light tower and its inability to shine its light above the houses built nearby prompted the construction of a steel structure that stood 105 feet above the ground and 130 feet above sea level. Painted brown, the light tower was first illuminated on April 17, 1896, at a cost of $8,768. A fixed green light at the apex was first used on August 1, 1920, when the light tower went electric; previously, it had been a white and then a red light. The keeper of the lighthouse (then called the light tower), and his family, and finally town employees, resided in the charming Victorian cottage from 1838 until around 1957, when it was razed. (*Circa* 1898 photograph by Herman Parker; courtesy Parker Collection.)

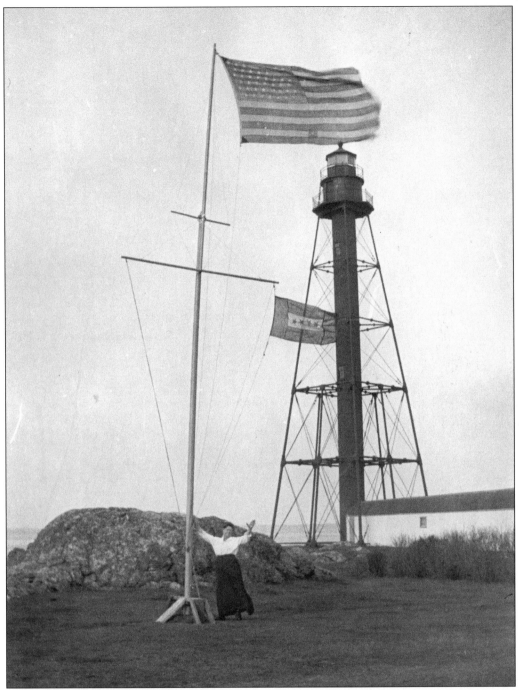

**A VICTORIOUS WAVE, 1917.** Mrs. Henry T. Drayton probably made the special flag with four stars to honor her four sons who were in the service during WWI. Her husband took charge of the light tower on May 1, 1893, and they lived in the adjacent cottage until his death in 1930. The first lighthouse keeper was Ezekiel Darling, a sailor on the *Constitution*, and Miss Jane Martin, who learned the duties from her lighthouse-keeper father, succeeded Mr. Darling. (Courtesy Cutler Collection.)

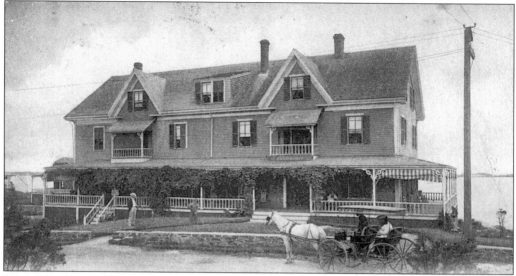

**THE OCEANSIDE, 1905 POSTCARD.** Guests arrive at the summer resort, formerly located on Ocean Avenue, in horse-and-buggy fashion to enjoy the amenities offered by A.H. and E. Lane, who were the proprietors around 1910. (Courtesy Maurais Collection.)

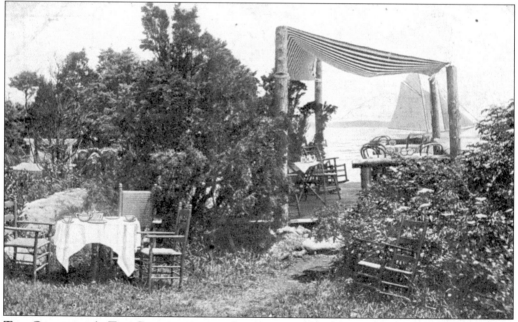

**THE OCEANSIDE'S TEA GARDEN BY THE SEA, C. 1920 POSTCARD.** Afternoon tea was served on a deck under a striped canopy or on the grass under the sun. Different style chairs, white linens, and a colorful tea service were popular then as they are today. The Oceanside was also "famous for its shore and chicken dinners." (Courtesy Swift Collection.)

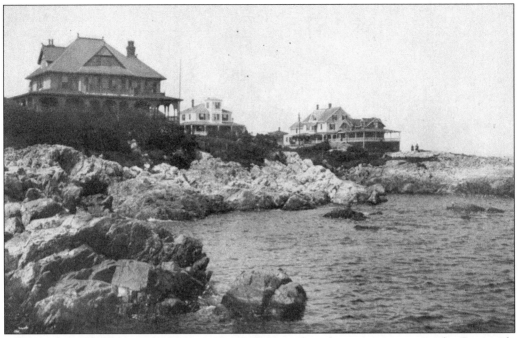

**ROCKS NEAR THE OCEANSIDE HOUSE.** Two ladies stand on the promontory near the Oceanside House (also referred to as the Oceanside Hotel), second building from the right, before the addition at the left doubled the size of the vacation resort. Wraparound piazzas grace all the structures at this scenic spot. (*Circa* 1910 photograph by Fred B. Litchman; courtesy McGrath Collection.)

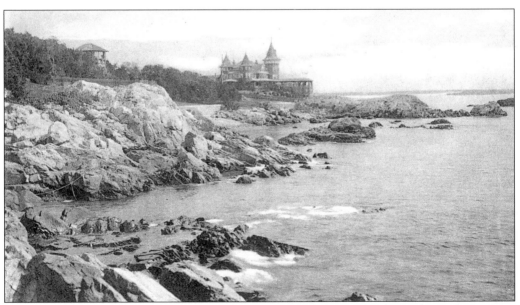

**ROCKS NEAR QUESTENMERE.** Artists, and those not so gifted, see splendor in the crashing waves along the rocky New England coastline, especially on the Atlantic Ocean side of Marblehead Neck. (*Circa* 1910 photograph by Fred B. Litchman; courtesy McGrath Collection.)

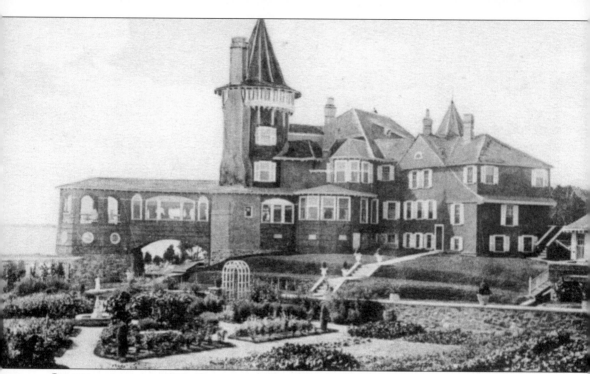

QUESTENMERE, C. 1909 POSTCARD. The Questenmere was formerly on Ocean Avenue opposite Manley Street Frank B. McQuesten, the first rear commander of the Corinthian Yacht Club, added his surname to the sprawling shingle-style home that he had built around the turn of the century. The tall, octagonal roof tower (one of three) and the wide, arched opening under what may have been the dining room, were distinctive architectural features. A professional gardening crew maintained the manicured seaside garden, with its centrally situated cast-iron fountain. (Courtesy McGrath Collection.)

**THE "CHURN."** A dangerous but intriguing rock formation, the Churn (once located off Ocean Avenue), was a favorite destination for watching the surf, as it crashed and sprayed between 40 and 50 feet in the air in the V-shaped crevasse of this natural wonder. Dynamite blasting of the site by the property owner in the mid-20th century made the Churn, or "Spouting Horn," a visual treat of the past. (1875 stereo view; private collection.)

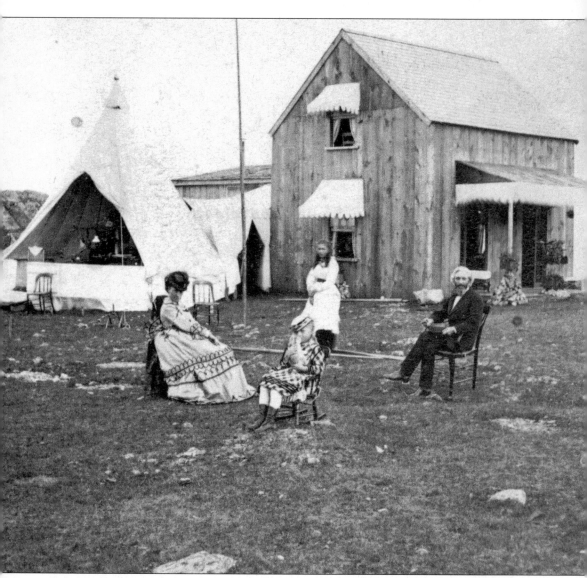

**THE HOUSE AND TENT OF MR. AND MRS. CHARLES P. WELLS.** The tepee-shaped white tent and the scalloped awnings on the two-story, vertically sheathed cottage at the corner of Ocean Avenue and Horton Corners imparts an air of fantasy to this summer setting. Family members are seated on living room chairs (long before the advent of patio furniture), and potted plants decorate the front entrance. This simple cottage is similar to ones built in Nashua, New Hampshire, in 1867, which were then disassembled and brought to Marblehead Neck, where they were reerected as the first permanent dwellings in the area (see map, p. 9). Campers from Lowell and Lawrence, Massachusetts, were the first people to sublet lots on the ocean side of the Neck. (*Circa* 1875 stereo view; private collection.)

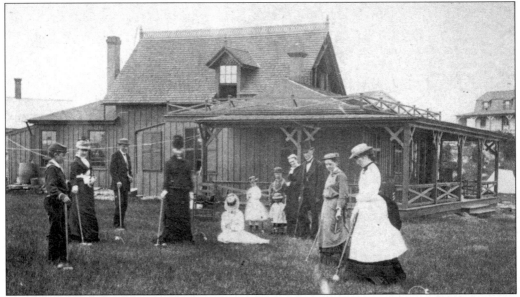

A GAME OF CROQUET ON THE BRODHEAD LAWN, OCEAN AVENUE . Members of the Brodhead and Wells families take part in a favorite out-of-doors game of the Victorian period. The wide, wraparound, rustic-looking porch could accommodate all on either sunny or rainy days. (*Circa* 1875 stereo view; Private Collection.)

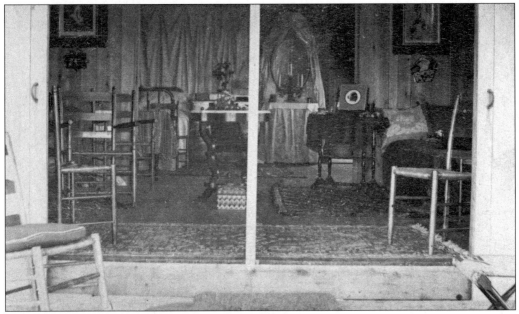

"OUR COTTAGE AS IT WAS UNTIL THE SUMMER OF 1874." John S. Moulton, a Salem photographer, took this and other images of the Brodhead and Wells families at their seasonal residences, and made them into stereo views so they could remember the pleasures of the Neck during cold winters by their cheery hearths. This provocative interior reveals a daybed, rugs on the wood floor, two Victorian occasional tables (one with a photograph or print of a favorite dog), and the gracefully draped fabric over Mrs. Brodhead's dressing table. (1871 stereo view; private collection.)

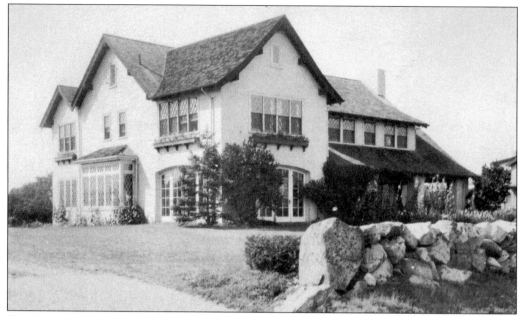

**THE JOHN P. BENSON HOUSE, 376 OCEAN AVENUE, C. 1912.** The Salem-Marblehead marine artist designed this dwelling, which was built around 1910. Sets of narrow casement windows with their diamond-shaped sections of glass and second-story window boxes imparted additional charm to the stucco cottage. The house also became the residence of Mr. Benson's brother, Henry P. Benson, a mayor of Salem. (Private collection.)

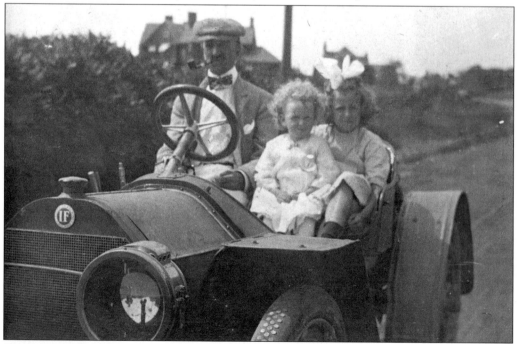

**THE LITTLE RED ISOTTA.** A Salem gentleman takes his daughter and niece for a ride around the Neck, where they are spending the summer months. (*Circa* 1912 stereo view; private collection.)

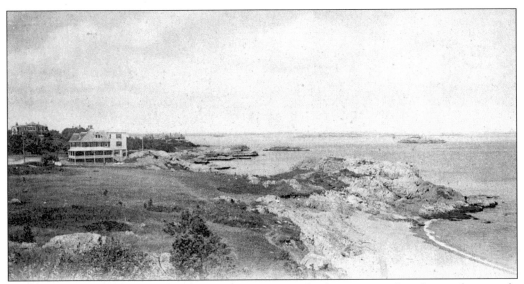

A VIEW OF THE BAY FROM THE NECK, C. 1905. The large mass of rock—predominately granite and petrosilex on the Neck—projecting into the Atlantic Ocean is known as Castle Rock. It has been a favorite spot to scan the horizon and to watch the comings and goings on the water since the days when Nanepashemet ruled the local Naumkeag Indians, and well before. (Courtesy Swift Collection.)

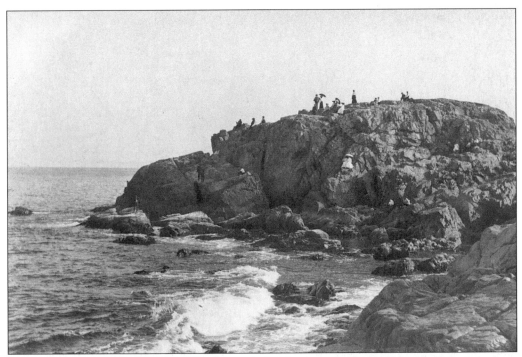

CASTLE ROCK, OCEAN AVENUE. The dirt path that leads to Castle Rock (to the left of chateau-like "Carcassonne,") has been well trodden for generations. The ascent and descent of "Great Head," which may be a translation of the Indian name, requires careful footing. However, the superb panorama is worth the effort. (*Circa* 1900 postcard; courtesy Maurais Collection.)

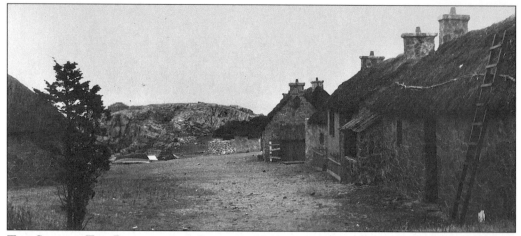

**The Set for *The Pride of the Clan*, c. 1916.** A Scottish village street scene was put up near Castle Rock for the early film that included some townspeople. Maurice Tourneur was the director, Lucien Andriot was the cameraman, and the supporting cast consisted of Kathryn Brown Decker and Warren Cook. As an extra in the silent movie, 'Header Sam Hiller rang a bell. When he joined others for luncheon at the "Eastern," he was heard to remark that the consommé looked and tasted like it came from 60 fathoms below the Grand Banks.(Courtesy Goddard Collection.)

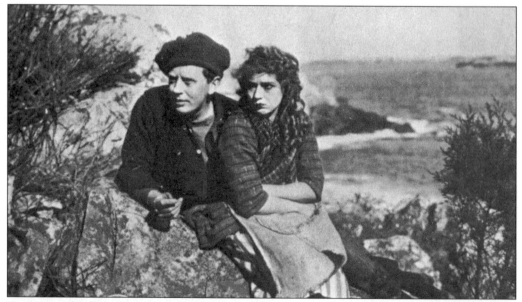

**A scene from *The Pride of the Clan*.** Lovely 23-year-old silent film star Mary Pickford left Fort Lee, New Jersey, to play the lead in the production at Castle Rock in October 1916. "Margaret's" role was played opposite Matt Moore, her husband Owen's brother. Litchman played an important part in the production as he tested the film's correct exposure every day at his studio. (Photograph by Fred B. Litchman; courtesy Goddard Collection.)

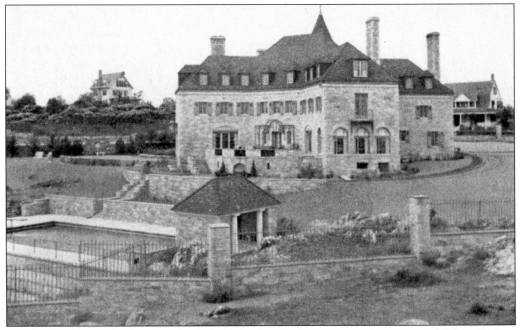

CARCASSONNE, 373 OCEAN AVENUE, 1936. Aroline C. Gove, the only daughter of Lynn medicinal entrepreneur Lydia E. Pinkham, built this French Gothic stone chateau known as the "Castle" next to Castle Rock in the 1930s with the help of unemployed local men during the early years of the Great Depression. It remains virtually unchanged today, and is still one of the most distinctive and admired mansions on the Neck. Mrs. Gove was the treasurer and general manager of her mother's company, which sold an alcohol-based liquid supplement to help many emotionally and physically incapacitated middle-aged women. (Courtesy Swift Collection.)

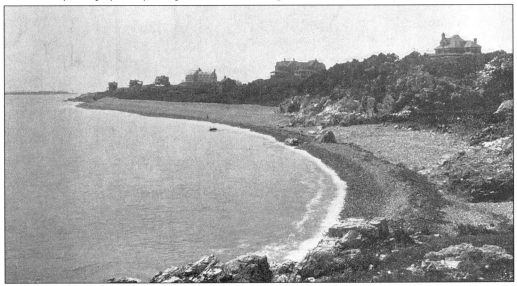

LONG BEACH. Crescent-shaped Long Beach is adjacent to Castle Rock, and was often referred to as "Ballast Beach," as stones from the area provided weight for the holds of vessels. Most of the turn-of-the-century mansions on the bluff have been remodeled to meet changing family needs. (*Circa* 1900 photograph by Fred B. Litchman; courtesy McGrath Collection.)

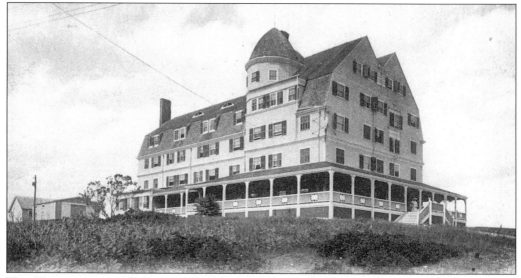

THE NANEPASHEMET HOTEL, C. 1905. Formerly located at the corner of Nanepashemet Street and Ocean Avenue, this impressive shingle-style hostelry was built in 1881 by Robert C. Bridge and opened for business the following year. Named for the local Indian sachem who was killed in a 1619 battle, the hotel was 60 feet above sea level, contained 80 rooms, and had an ocean breeze–swept wraparound piazza. Paul Brackett purchased the Nanepashemet in 1914, renamed it the Ocean Manor, and only operated the hotel until October 21 of that year, when it was consumed by flames. (Courtesy Swift Collection.)

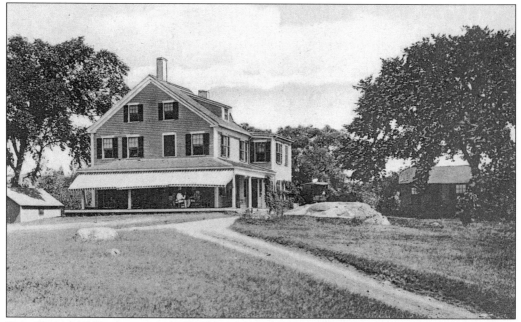

THE "BRIDGE" FARMHOUSE, 230 OCEAN AVENUE, C. 1905 POSTCARD. One of the earliest guesthouses on the Neck, this mid-19th-century farmhouse had a rural appearance that was enhanced by mature trees in summer's full leafage. A dark-green and white awning shielded guests against the sun's rays as they enjoyed the view in the direction of Swampscott, Lynn, and Boston. (Courtesy Maurais Collection.)

## Four

# REDGATE: A SUMMER HOME ON THE NECK

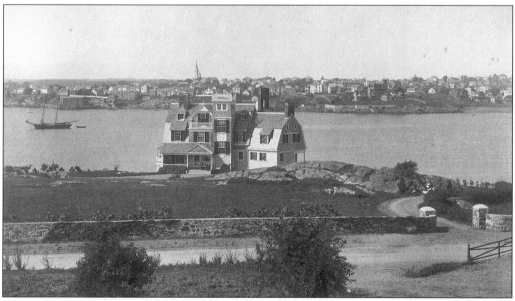

**REDGATE, C. 1888.** Near the intersection of Foster Street and Harbor Avenue is this picturesque Colonial Revival–style mansion built in 1886 for Boston businessman Charles Wallingford Parker. It is in marked contrast to the mainly modest 18th- and 19th-century dwellings constructed in the town for its less wealthy and less socially prominent inhabitants. Mr. Parker (1831–1915) made his fortune as president of the textile firm Macullar, Parker, & Company, which enabled him to acquire this prominent location not too distant from the end of the Causeway. Charles (C.W.) and Mary Jane Parker and their five children spent their summers enjoying the scenic pleasures at "the largest and most interesting estate" on the Neck until around 1911. (Courtesy Parker Collection.)

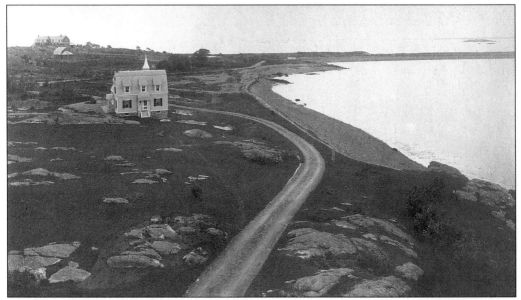

**REDGATE COTTAGE, 1888.** Charles W. Parker's second son, Herman, took this picture and others in this chapter that pertain to his family's ownership of Redgate. Taken from an upper window of the main house, the photograph shows the smaller house on the property. The absence of trees and shrubbery is evident on the rocky terrain adjacent to a beach with Redgate Bay and the Causeway in the distance. Mr. Parker's 5.5-acre property was situated off Foster Street, which follows the shoreline off Harbor Avenue. It was bounded by that street, Parker Lane, and Marblehead Harbor. (Courtesy Parker Collection.)

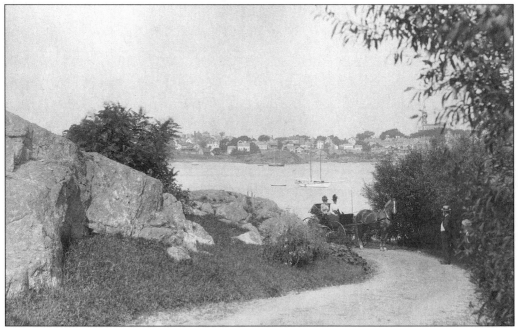

**A LEISURELY CARRIAGE RIDE, 1888.** Two female members of the Parker family enjoy a summer's day ride on the dirt road of the Redgate property and are greeted by the patriarch and a young relative (perhaps a grandson) or friend. (Courtesy Parker Collection.)

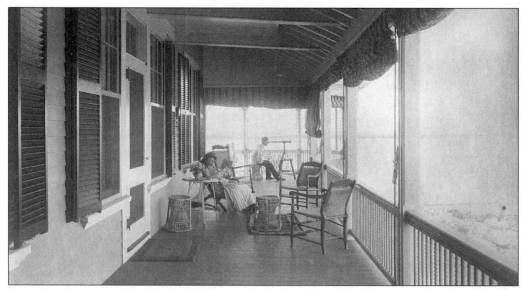

**SOME FAMILY ACTIVITIES ON THE PIAZZA, 1888.** This was an ideal spot to view goings-on in the harbor with a powerful telescope, to relax in a comfortable chair with a special book, or maybe to strum a few chords on a mandolin. The fancy striped awnings, lowered to different levels, added flair to the piazza and provided shade for the family and their friends. Charles S. Parker, the first-born son, may be the gentleman manning the telescope. (Courtesy Parker Collection.)

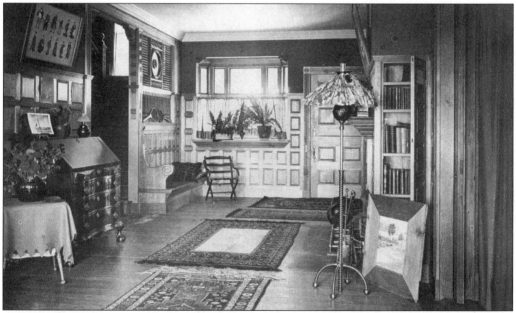

**THE FRONT HALL, 1888.** Raised paneling on the wainscotting, Dutch door, and settle create a formal background for the furniture and furnishings brought by the Parkers to their summer home. The shimmering surface of a Massachusetts Chippendale reverse-serpentine slant-front desk with ball-and-claw feet is visible near the doorway that reveals the main stairway. A landscape in a wide frame, probably painted by Charles S. Parker (1860–1930), is displayed against the pocket doors that lead to either the living room or the dining room. (Courtesy Parker Collection.)

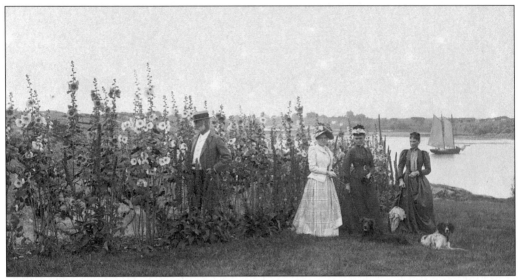

**PARKERS AND HOLLYHOCKS, 1886.** C.W. Parker appears more interested in his glorious stand of multicolored hollyhocks than in the trio of female companions with their pet dog on the lush lawn. Shown, from left to right, are Lillian P. Parker, Mary Parker, and Mary Jane Parker. A writer noted that the estate was "arranged and planted with such skill and taste as to call forth the enthusiastic commendation of the many expert horticulturists who have visited it, and pronounced by them a model for the treatment of such places on our rocky shores." (Courtesy Parker Collection.)

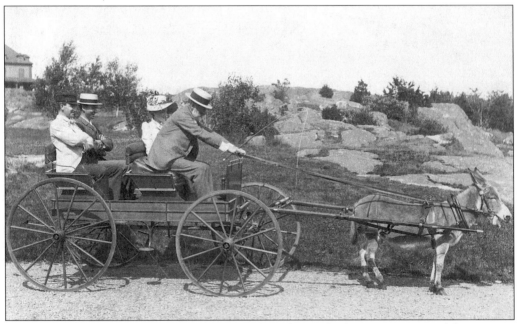

**"GIDDYAP," C. 1890.** Bessie the donkey looks exhausted after carting around her owner, Charles W. Parker, sons Charles S. (far left), Ross (the third male), and Lillian P. Parker, whose husband, Herman, snapped the amusing picture. During his artistic career, Charles S. Parker sculpted the seal of Pegasus over the Trophy Room mantelpiece in the Corinthian Yacht Club. (Courtesy Parker Collection.)

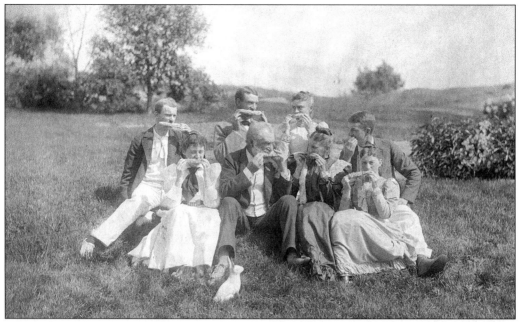

A "CORNY" GROUP, C. 1895. Freshly picked and recently cooked home-grown corn-on-the-cob is being devoured by the Parkers, who remain almost as silent as the cast-iron rabbit. Shown, from left to right, are Herman (who took the picture by pulling the cord behind his leg), his wife Lillian, Charles Schoff, Charles W., Mary, Mary Jane Schoff Parker (C.W.'s first wife), Ross, and Morgiana Heath Schoff (who married Mr. Parker around 1900 after her sister Mary Jane died). (Courtesy Parker Collection.)

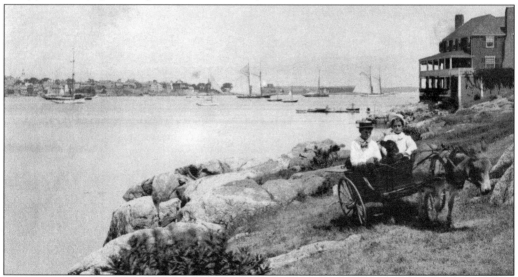

BESSIE AND HER FRIENDS, C. 1895. The Parker family's most unusual pet, and a special mode of transportation on their property, trudges the rocky terrain of Redgate while pulling a smaller vehicle with less occupants than in the opposite picture. Situated at the end of Parker Lane, the house with the distinctive end chimney (still visible from the Causeway) was built with a two-story piazza to afford twice the viewing pleasure of the harbor and its sailing craft. (Courtesy Chadwick Collection.)

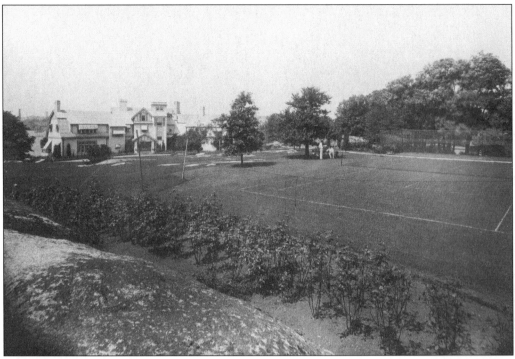

**REDGATE, C. 1917.** Almost unrecognizable, save for the geometric panel in the tower, the Parker family's former summer home was given an updated look by second owner Frederick C. Fletcher's architect after the textile manufacturer acquired the property in 1913. Large gambrel-roofed ells and chimneys were added to both sides of the newly stuccoed and timber-accented building. The Fletcher family summered at Redgate until 1926, when the property changed hands for the second time. (Courtesy Selina Fletcher Little.)

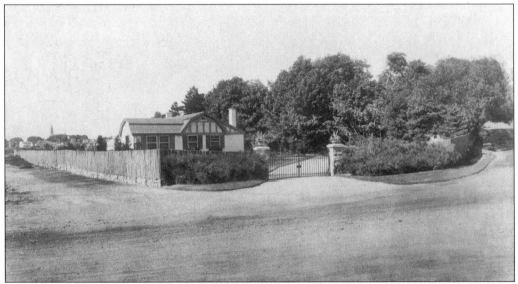

**THE MAIN ENTRANCE TO REDGATE, C. 1917.** Stone gateposts flank the entrance to the driveway at 2 Foster Street. The modest stucco and timber-framed lodge (or gatehouse) may have been used as an artist's studio by Charles S. Parker. (Courtesy Little Collection.)

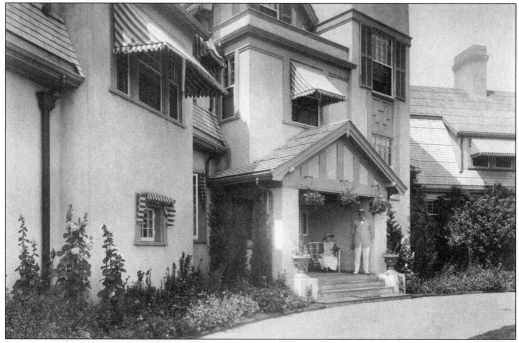

**MR. AND MRS. FREDERICK C. FLETCHER, C. 1917.** Frederick Fletcher, a model ship collector, and his second wife, Alice Ida Benn, may be awaiting their chauffeur to take them to the yacht club, to a reception or party, or perhaps to afternoon tea at a neighbor's home. Hanging and potted plants grace the pedimented front doorway of Redgate, giving color and fragrance to the enclosed entrance. (Courtesy Little Collection.)

**NINA J. FLETCHER, C. 1917.** The only child of Frederick C. and Selina Jarvie Fletcher poses in a wicker armchair in front of the cottage on the Redgate property. As Nina Fletcher Little (1903–1993), she became a greatly admired scholar, author, and collector in the fields of American decorative arts and folk art. (Courtesy Little Collection.)

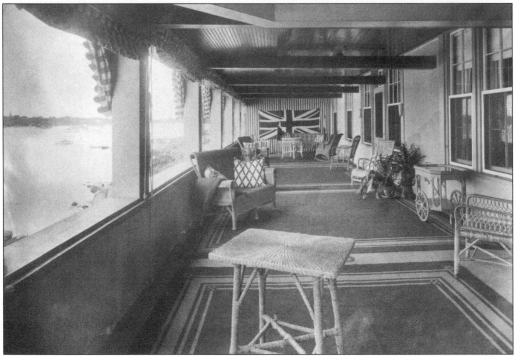

**THE HARBORSIDE PIAZZA, C. 1917.** Four plain and bold geometric rugs define seating areas noticeably devoid of objects on the rope and wicker tables and tea cart. The Union Jack, a symbol of Mrs. Fletcher's WWI patriotism, makes a dramatic focal point against the striped awning. (Courtesy Little Collection.)

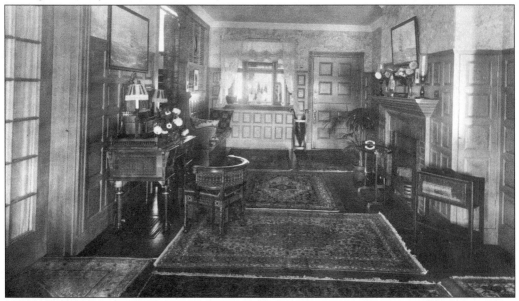

**THE FRONT HALL, C. 1917.** A late-Victorian diminutive secretary and a roundabout armchair in a quasi-Moorish style are featured in this view along with other furnishings and Oriental carpets of different sizes. The cheery fireplace warmed the area during cool late-summer and early-fall days when the fog rolled in. (Courtesy Little Collection.)

THE MORNING ROOM, C. 1917. This room reflected the English flair of Mrs. Fletcher, who decorated it with floral chintz fabric, framing the windows and covering the comfortable armchairs. Family photographs are tastefully placed around the room and also grace the mantelpiece with its assorted *objet d'art*. (Courtesy Little Collection.)

THE PARLOR, C. 1917. Sunshine filters into this room, with its built-in, conforming bay window seating arrangement. The Colonial Revival wooden mantelpiece (always painted white at that time) has barley-twist columns. A framed picture of the Fletcher coat-of-arms has been placed at the right, and a yachting certificate awarded to Capt. Frederick C. Fletcher, is at the left. (Courtesy Little Collection.)

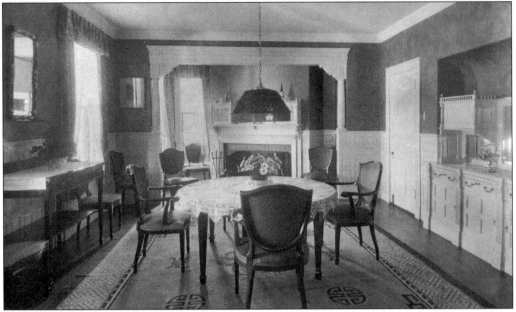

**THE DINING ROOM, C. 1917.** A flat-topped archway with a pulvinated frieze separates the tile-decorated fireplace mantel from the extendable circular dining table covered with a crotched tablecloth. The built-in sideboard with a mirrored back mimics the gallery of the mantelpiece, both painted a fashionable white. (Courtesy Little Collection.)

**MRS. FLETCHER'S BEDROOM, C. 1917.** The lady of the house could rest during the day on the wicker chaise lounge located near the foot of her brass bedstead. A sterling silver repoussé dresser set and a fancy hatpin holder in the shape of a doll repose on the bureau with other toiletries. Some family photographs surround the Adamesque-style mirror above the mantelpiece with its "eared" molding. (Courtesy Little Collection.)

# Five

# YACHTING HIGHLIGHTS

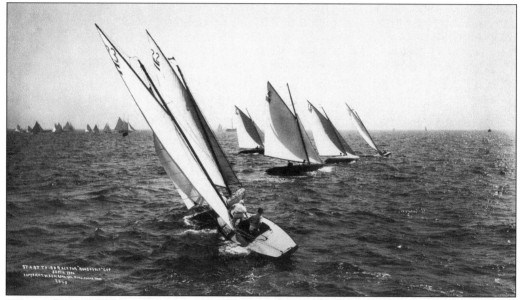

"START [OF THE] THIRD RACE FOR [THE] 'ROOSEVELT CUP.'" As early as 1851, a reporter in *Gleason's Pictorial Drawing-Room Companion* wrote, in conjunction with an accompanying wood engraving, that "yachting has become of late, not only in this country, but in Europe, a favorite species of amusement for gentlemen of leisure. We are not sure but that it is rivaling in a measure the famous interest of the turf, which has so long held sway among sportsmen." Indeed, as noted in chapter 3 of this book, yachting clubs began to make their appearance in picturesque spots along the eastern seaboard of America shortly after the Civil War, with Marblehead becoming a prime location. In the town directory for 1914 under the heading "historical events" is listed the following: "Sept. 10, [1906], Roosevelt Cup won by American Yacht *Vim* in yachting contests between Germany and America." (1906 photograph by Willard B. Jackson; courtesy Woods Collection.)

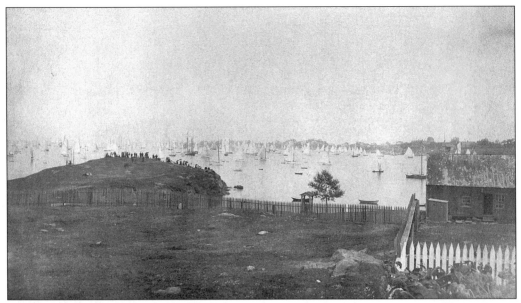

YACHTS GATHERED IN MARBLEHEAD HARBOR AT THE BEGINNING OF THE GREAT RACE, AUGUST 20, 1883. Residents of the town celebrated the nation's centennial on July 4, 1876, with a parade, dinners, and a regatta (a boat race). Seven years later, when this historic photograph was taken of an early race week by an unidentified photographer, the harbor was filled with sparkling white sails, as seen by these inhabitants and visitors perched on Skinner's Head. (Courtesy Mr. and Mrs. Garrett D. Bowne.)

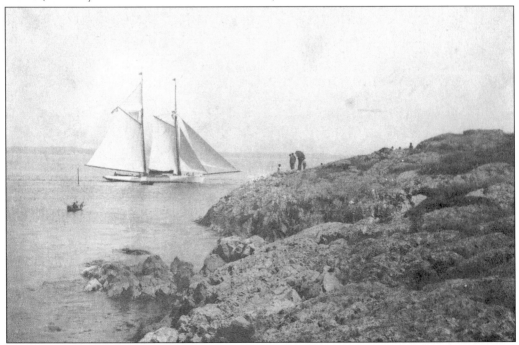

"ALICE, OFF MARBLEHEAD LIGHT." This schooner yacht is shown leaving the harbor for the Corinthian Yacht Club race on July 23, 1891. (Photograph by Herman Parker; courtesy Parker Collection.)

100

**THE REGATTA OF THE EASTERN YACHT CLUB.** The sloop yachts *Mayflower* (left), and *Priscilla* cross tacks while chasing the *Puritan* in this regatta off Marblehead in 1886. *Puritan* (1885), *Mayflower* (1886), and *Volunteer* (1887) were designed by Edward Burgess for Gen. Charles J. Paine, who single-handedly managed the defense of the America's Cup for three successive years. *Puritan* and *Mayflower* were built at the yacht yard of George Lawley in South Boston; both were constructed of wood and their sails were sewn by Charles McManus, also of Boston. *Volunteer* was built of steel by Pusey and Jones Shipbuilding Corporation in Wilmington, Delaware. Unlike later cup defenders, which were out-and-out racing machines, all three of these sloops were later converted to schooner rigs and provided their owners with many hours of pleasure cruising the American coast. (1886 wood engraving.)

**SAILING PAST PRIESTS' ISLAND, EARLY 1900S.** The *Brenda* of Swampscott was a typical turn-of-the-century cruising sloop, very comfortable and easy to handle. (Courtesy Bull Collection.)

**AN EARLY "ACTION" STUDY, 1882.** The brother of Salem artist Philip Little (1857–1942), David Mason Little studied naval architecture at the Massachusetts Institute of Technology (MIT). He was a fine silversmith working in the Arts and Crafts tradition, a boat builder, a maritime photographer, and an author. Regarding the many photographs he took of vessels in motion, and those included in his 1883 book *Instantaneous Marine Studies*, Little wrote about "all the wearisome days [he has] spent on the billowy ocean." He noted that "the exposure was not more than the one-hundredth part of a second." (Photograph by David Mason Little, 1860–1923; courtesy Little Collection.)

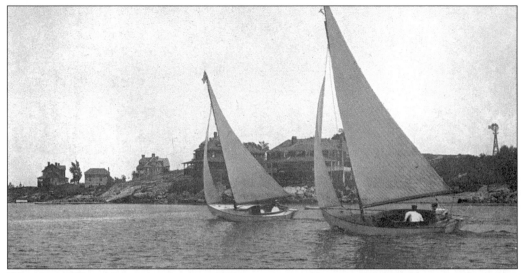

**"The First Knockabouts, Jane and Nancy in the Harbor," 1892.** "Intended for sailing in the rough water of Massachusetts Bay in all weathers," these knockabouts were built in Gloucester by Higgins and Gifford for Herman Parker and Henry Taggard. "Raceabouts" (which had short bowsprits) and "knockabouts" (which had no bowsprits) were tremendously popular small sailing crafts until Massachusetts Bay 18-footers superseded them. "Untearable" and "wear-resisting" patented knockabout suits for boys between the ages of three and ten were being sold in Boston (and probably locally) at this time for $5. (Courtesy Swift Collection.)

**Two Early Knockabout Trophies.** Most trophies awarded by the local yachting clubs to its members for outstanding sailing performances were made of sterling silver, and many have been returned to the clubs to be displayed along with other memorabilia of historic importance. The Eastern Yacht Club's impressive Puritan Cup is actually a tall pitcher with a seated mermaid designed to be the lid's thumbpiece; other repoussé mermaids with flowing tresses swim around the cup's sides, with its various inscriptions, including the names of winning yachts, their owners, and those dates of distinction. (Early-20th-century photograph; courtesy Parker Collection.)

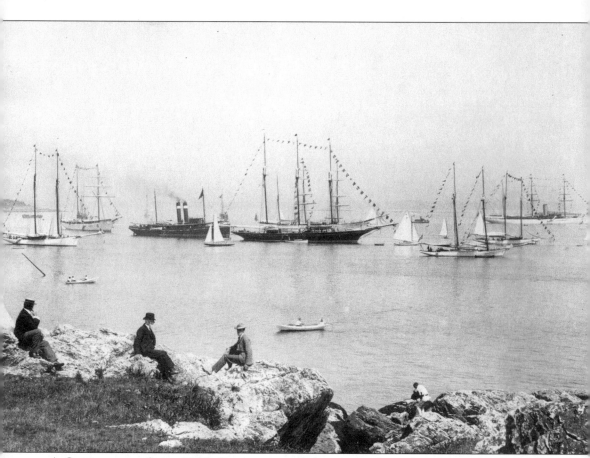

A Celebratory Sail, 1905. One-, two-, and three-masted vessels strung with colorful flags and pennants sail past seated onlookers at Point o' Rocks in the early 20th century. In 1940, the summer menu from the restaurant of Boston's Filene's department store featured a cleverly amusing paragraph on the back cover about Marblehead Harbor: "A sailor's town . . . where fingers which do not bear the tarry callouses of the true seaman are the exception. Wee nippers in sunsuits man their cats with all the skill and finesse of an America's cup defender. Delicious looking girls in dirty ducks and Basque shirts exchange the jargon of the sea (with overtones of Vassar or Mt. Holyoke) with red faced, rhino-skinned old sea dogs who taught them to trim a sheet when they were scarcely able to walk. Bronzed young men, lugging gear, hail each other across narrow streets. Marblehead, the racing center of America! Truly a sailor's town—and Race Week is its apogee." (Photograph attributed to Fred B. Litchman; courtesy Chadwick and Swift Collections.)

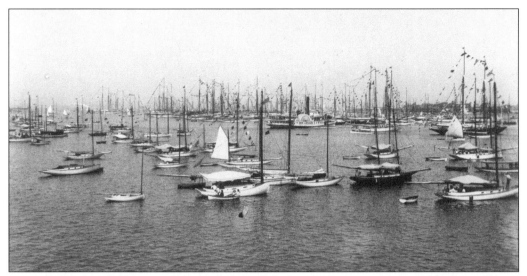

RACE WEEK, 1902 POSTCARD. The New York fleet sailed into Marblehead Harbor for many seasonal visits beginning in the late 19th century, here surrounding the *General Lincoln*, a typical sidewheel passenger steamer in the Boston commuter fleet. Two years before mid-century, yachting regattas were taking place off the town and neighboring Swampscott. In 1907, there was an open series during Race Week when 107 sailboats crossed the starting line, with such well-respected skippers at the helms as Charles Francis Adams, B. Devereux Barker, Charles F. Curtis, C.H.W. Foster, Caleb Loring, and Lawrence F. Percival, who was commodore of the Corinthian Yacht Club between 1920 and 1922. (Courtesy Chadwick Collection.)

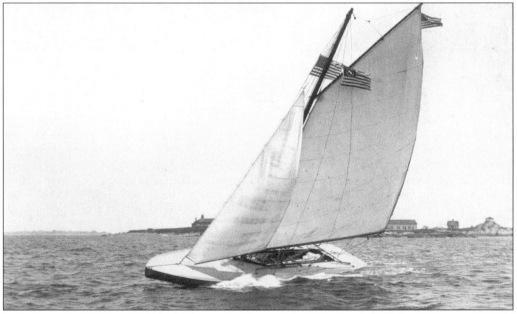

MANCHESTER, 1905. Lightly built racing sloops of a scow-type hull form were extremely popular around the turn of the century; they were deservedly referred to as "skimming dishes." Franklin E.S. Thompson, whose shop was located at 103 Washington Street between 1903 and 1948, advertised that he was a "marine fo·to·grapher." (Photograph by Willard B. Jackson; courtesy Chadwick Collection.)

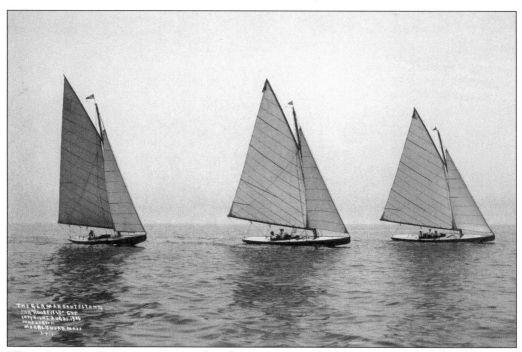

**"The German Contestants for [the] 'Roosevelt' Cup, August 21, 1906."** Sloops of the Sonder Klasse (Special Class) were introduced from Germany around this time, and were appealing to racing enthusiasts in America before WWI. (Courtesy Bull Collection.)

**L. Francis Herreshoff, c. 1930.** A native of Bristol, Rhode Island, and the son of esteemed yacht designer Capt. "Nat" Herreshoff, L. Francis Herreshoff (1890–1972), moved to Marblehead in 1926 to distance himself from his sire. Working on his own account, he enjoyed a distinguished career as a designer of innovative racing machines and practical, comfortable cruising boats. The author of several books and a contributor to the *Rudder*, a nautical magazine, L.F. Herreshoff resided in the stone fortress, "Ballard's Castle," adjacent to Crocker Park, and enjoyed his bright red sports car in his later years. (Courtesy Woods Collection.)

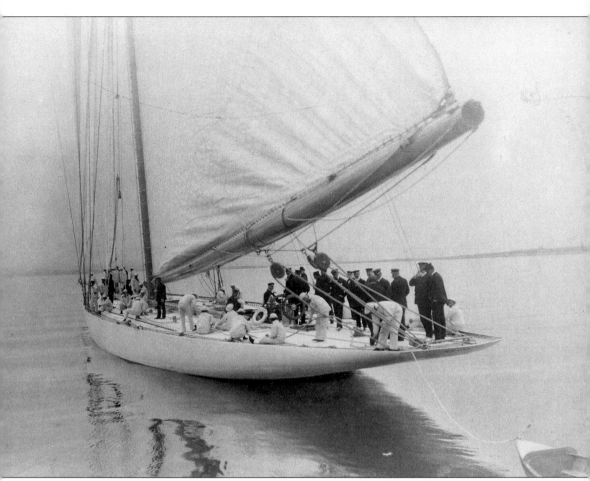

**THE RELIANCE, C. 1905.** Perspective intensifies the angle of the boom and the prominent overhang of this sleek yacht's steel stern. Designed and built in Bristol, Rhode Island, by Nathanael G. Herreshoff (1848–1938), the *Reliance* was the largest of the fin-keel racing sloops (his own design) and had a huge mainsail. The *Reliance* was one of six America's Cup defenders designed by Herreshoff, who had attended MIT briefly. The celebrated "Wizard of Bristol" became a member of the BYC in 1886 and enjoyed the camaraderie and sportsmanship of the club's members until his death. (Courtesy Woods Collection.)

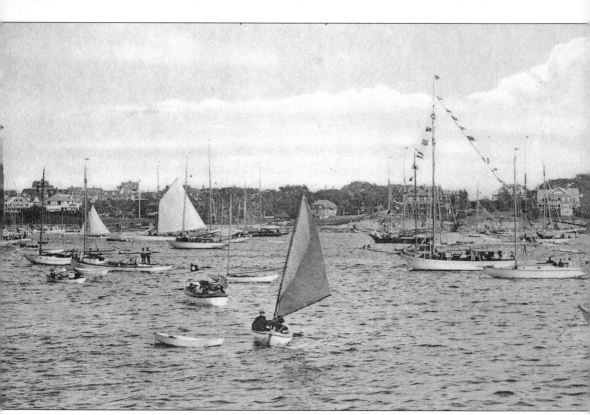

**ACROSS THE HARBOR FROM CROCKER PARK, 1905 POSTCARD.** Sleek yachts with colorful pennants blowing in the breeze flank prestigious houses on the Neck. On August 10, 1902, the harbormaster was somehow able to take count of 1,047 vessels of all shapes and sizes commingling in the harbor during the New York Yacht Club's 20th visit to Marblehead. Their various sailing craft alone included a squadron of 118 yachts, schooners, sloops, steamers, and auxiliaries. "Tens of thousands" eager yachting enthusiasts watched the regatta on Monday from every conceivable viewing spot. Receptions in the evening at the EYC and the CYC were held to honor special guests, and everyone in town was treated to a grand harbor illumination.

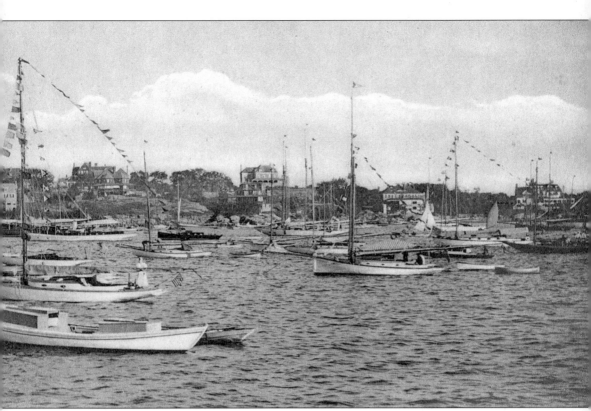

Small fires glowing red along the shore and intermittent changing colored lights on the many steam yachts helped to put a wonderful end to a day that drenched practically all who watched the impressive regatta. A contributor to the *Rudder* noted that "there is no yachting event on the wide waters of the world like the annual cruise of the New York Yacht Club . . . . There was a nice favoring breeze the morning the fleet disbanded [on Tuesday, the following day], and by noon nearly the whole of the big fleet had left Marblehead, some going to the east and some west." (Postcard made from a photograph by Fred B. Litchman; courtesy Swift Collection.)

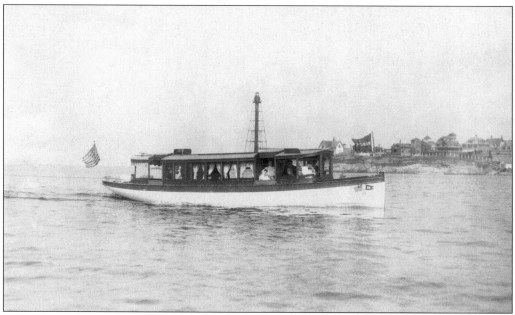

**THE WOGGIE, C. 1905.** The steel light tower at Point o' Rocks appears to be part of the gasoline-powered private launch as she makes her way into the harbor. (Courtesy Bull Collection.)

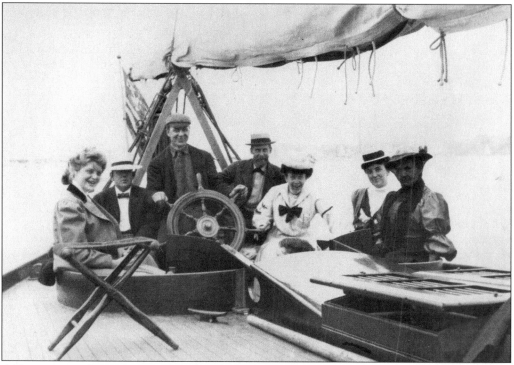

**A DELIGHTFUL SAIL, C. 1908.** Martha Elizabeth Parker (far left) and companions are dressed in their Edwardian finery for a cool afternoon sail aboard an unidentified yacht. The man emerging from the hatch has probably prompted everyone's good cheer. (Courtesy Cuzner Collection.)

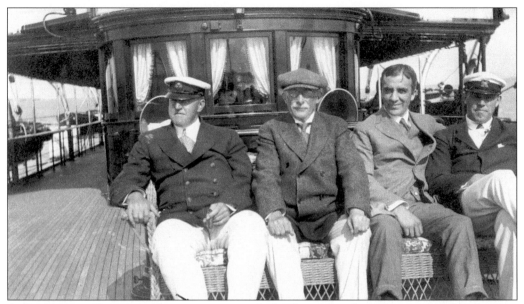

A QUARTET OF YACHTING ENTHUSIASTS, C. 1915. These relaxed gentlemen, two of whom sport nautical garb, pose on a wicker settee in front of the cabin on the deck of the steam yacht *Cristina*, anchored in Marblehead Harbor. From left to right are Capt. Frederick C. Fletcher (owner of the yacht); his father-in-law, Dr. William Jarvie; a friend, Herbert Yerxa; and nephew Charles Fletcher. SY *Cristina* was launched in 1911 by Pusey and Jones (mentioned previously), and she was enjoyed by the Fletcher family and their friends for four years until she was appropriated by the U.S. government for use by the Coast Guard during WWI. (Courtesy Little Collection.)

A CIGARETTE ADVERTISEMENT, 1906. Cocktails and cigarettes have gone hand-in-hand for more than a century and are especially enjoyed by the yachting set at the clubhouse or at related functions elsewhere. In this generic scene entitled "Yachting at Marblehead, Mass.," a handsome, "bronzed" young yachtsman offers a helping hand to a "delicious Gibson girl" wearing a trendy nautical outfit emblazoned with an anchor, and a flat-brimmed straw chapeau. (Illustration; courtesy Stanley S. Sacks Antiques.)

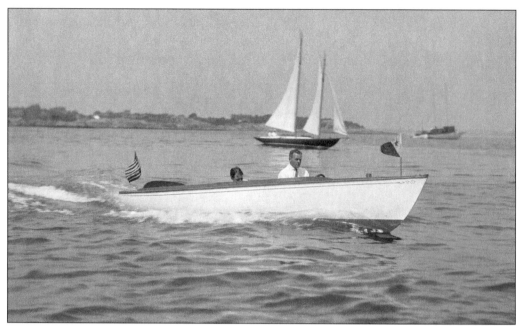

**THE *LYTTELWUN*, C. 1915.** Samuel H. Brown Jr., who resided with his family at Fort Sewall Terrace, studied naval architecture at MIT and built this runabout with his brother, Bill, in 1910. The intriguingly christened *Lyttelwun* displays the burgee of the Corinthian Yacht Club. (Photograph by Willard B. Jackson; courtesy Bull Collection.)

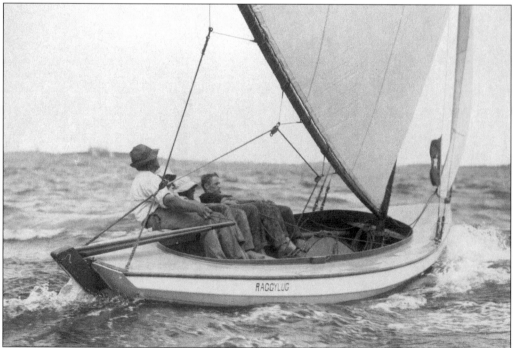

**THE *RAGGYLUG*, C. 1920s.** Skipper William H. Brown at the tiller with Sam (third from the left) and friends holding fast the sail, have won a season championship, as indicated by the fluttering pennant. (Courtesy Bull Collection.)

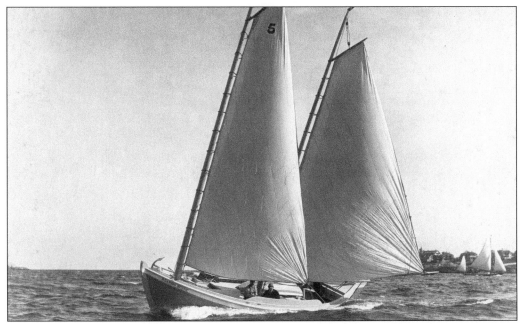

**THE *ROARING BESSIE*, 1911.** Martin C. Erismann, a naval architect, built the *Roaring Bessie* from the design of the *Lena M*, one of two old Block Island boats, before this historic type of vessel became extinct. Block Island boats were descendants of colonial shallops (two-masted open boats of heavy lapstrake construction). By the early 1800s, they had evolved into a unique local type, suited to the exposed shallow harbor and rough waters off Block Island. (Photograph by Willard B. Jackson; courtesy Bull Collection.)

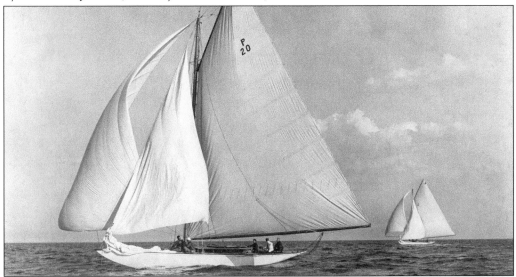

**THE *AMORET* AND THE *WINDWARD*, C. 1930.** Leading the *Windward*, and somewhat mirroring its curvaceous sails, is the *Amoret*, designed by George Owen at East Boothbay, Maine, in 1910 for John G. Alden of Boston. P-boats, as indicated by the letter on the *Amoret's* mainsail, were named for their classification under the Universal Racing Rule; other popular classes included J, M, Q, R, and S. The measurement rules were complex and allowed trade-offs between sail area, girth, and other hull dimensions. (Photograph by Willard B. Jackson; courtesy Bull Collection.)

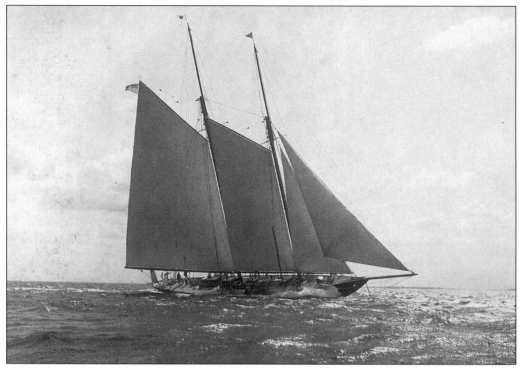

CLEOPATRA'S BARGE II, C. 1925. The Crowninshield family pennant is silhouetted atop the main mast of the high-grade steel-hulled schooner, which is close-hauled under "plain sail" (without topsails or flying jib). Built in 1916 by the Herreshoff Manufacturing Company in Bristol, Rhode Island, the vessel was christened the *Mariette* by first owner, J.F. Brown of Boston. However, *Cleopatra's Barge II*, as renamed and sailed by Capt. Francis "Keno" Crowninshield, is how she is remembered best of all. This schooner yacht is still sailing, now under her original name. (Photograph by Willard B. Jackson; courtesy Hammond Collection.)

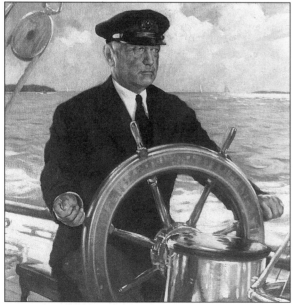

FRANCIS B. CROWNINSHIELD AT THE WHEEL OF CLEOPATRA'S BARGE II. Stern and steadfast Keno grasps the varnished wood-and-brass wheel of the schooner yacht named for the 1816 pleasure boat his ancestor Capt. George Crowninshield Jr. owned in Salem. When not in summer residence at "Seaside Farm" on Peach's Point (*Marblehead Vol. I*, pp. 70–71.), the F.B. Crowninshields could be reached by their many friends while they wintered at Boca Grande in Florida. (Photograph of the 1935 oil portrait by John Lavalle; courtesy Hammond Collection.)

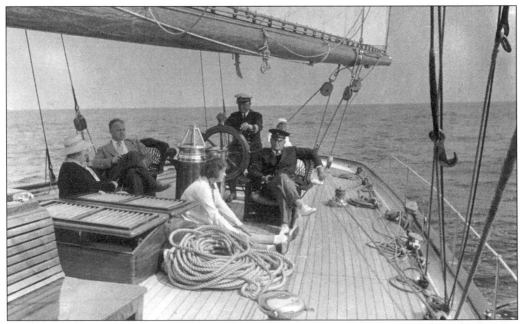

**A Pleasurable Sail on Cleopatra's Barge II, c. 1935.** The boom moves gently over the head of Capt. Crowninshield (seated right). His exceedingly wealthy wife, the former Louise DuPont of Wilmington, Delaware (far left), is engaging the gentleman next to her in conversation—possibly about her passion for American antiques and the arranging of them in the Marblehead Historical Society's Jeremiah Lee Mansion. An unidentified young woman remains silent for awhile. (Courtesy Hammond Collection.)

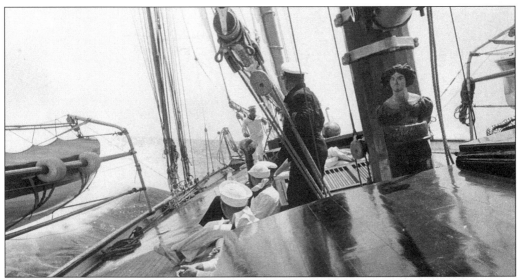

**Rough Seas for Cleopatra's Barge II, c. 1935.** The bust of a maiden, possibly similar to a figurehead that may have graced the bow of the first "barge," appears to be secured to the main mast much as was the fictional heroine of Henry Wadsworth Longfellow's 1841 poem "The Wreck of the Hesperus," before the schooner was wrecked off Norman's Woe on the Manchester-Magnolia coastline during a ferocious storm. (Courtesy Hammond Collection.)

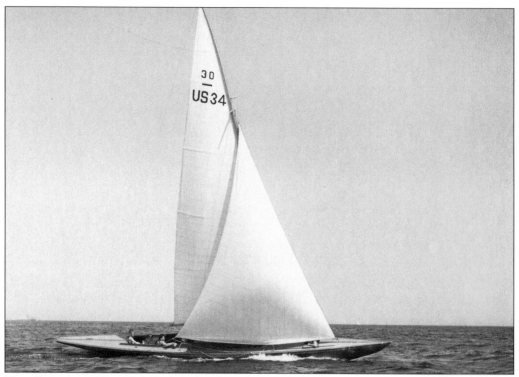

**THE *ROULETTE II*, 1936.** Sailing hard on the wind, these fellows have doffed their shirts to get a suntan aboard the 30-square-meter sailboat designed by F.M. Hoyt, and built in 1927 by Henry B. Nevins Inc., at City Island, New York, for local owner Ray Craerin. (Photograph by Willard B. Jackson; courtesy Woods Collection.)

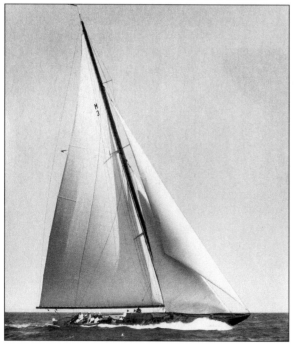

**THE *CHIORA*, C. 1930.** Charles L. Harding of Dedham and Marblehead, who joined the Eastern Yacht Club in 1907, purchased this Herreshoff-designed wooden sailboat in 1926. She was christened the *Iroquois II* when built in 1913. Originally a New York 50-foot-class racing sloop, the *Chiora* was rerigged to race in the Universal Rule's M Class in the 1920s. (Photograph by Willard B. Jackson; courtesy Woods Collection.)

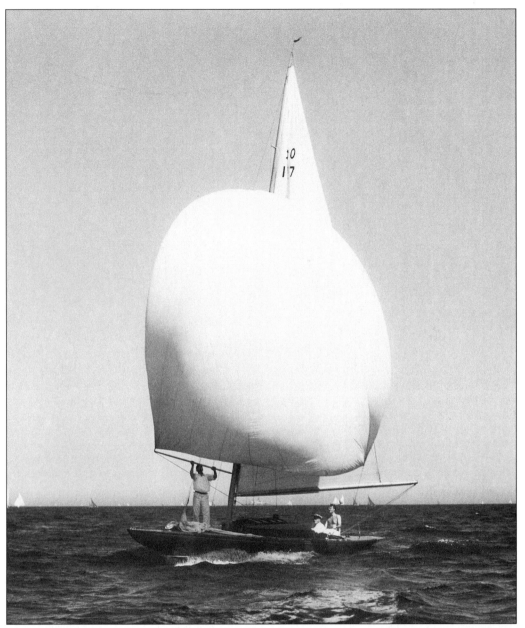

THE *BRILLIANT*, C. 1935. Yachtsmen aboard the 30-square-meter sloop (nicknamed "Thirty-Squeaks") are pleased that the spinnaker is drawing so well as they run before the wind. The *Brilliant* was built in 1932 by Henry B. Nevins for Walter Barnum of Larchmont, New York. (Photograph by Willard B. Jackson; courtesy Woods Collection.)

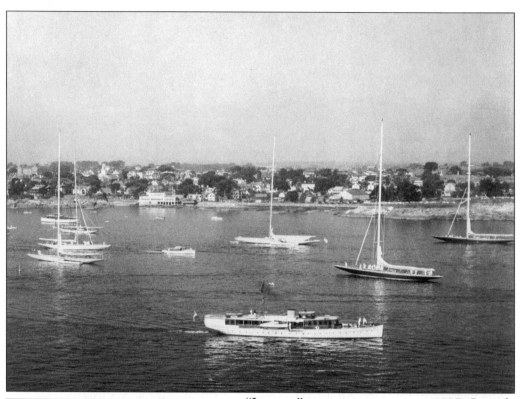

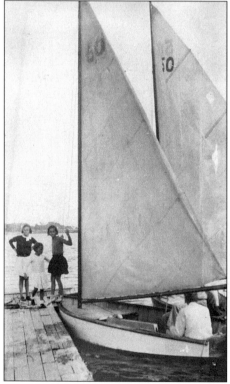

**"J-BOATS" AND A STEAM YACHT, 1937.** Several J-class sloops (so named for the rating category of J, under the Universal Yacht Measurement Rule, which was popular from 1920 to 1940) are admired by people on the steam yacht in the foreground. From left to right are the *Rainbow* and the *Yankee* (to the left of the Adams House Restaurant), and the *Ranger*, the *Endeavour II*, and the *Endeavour* (in the Fort Sewall area). After the 1937 defense of the America's Cup, when *Ranger* defeated *Endeavour II*, the J-boat fleet cruised the New England coast together; it was the last occasion when a class of racing sloops of 90-foot waterline length would ever do so. (Photograph by Willard B. Jackson; courtesy Bull Collection.)

**TWO DINGHYS OF THE "BRUTAL BEAST" CLASS, C. 1933.** Robert C. Seamans Sr., a resident of what was then 5 Harbor View, is seated in the stern of his Brutal Beast, which was christened *Daylight*. Starling Burgess designed the first small vessel of this type for his children before 1921, and they have been especially popular with young skippers. (Courtesy Abbot Collection.)

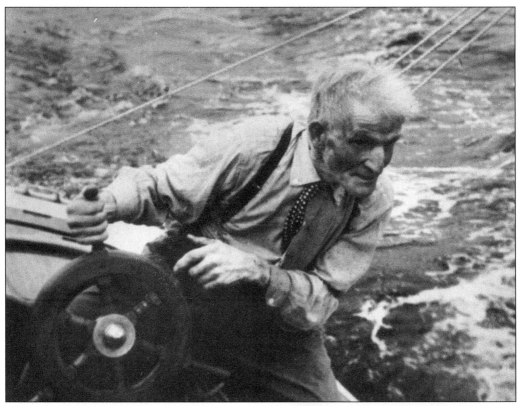

**HOLDING FAST IN A SQUALL, C. 1940.**
Not a young sailor when this action
picture was taken, Capt. Charlton Lyman
Smith (born in Chelsea, Massachusetts, in
1869) steers the *Nixie*, a keel cat designed
by Edward Burgess in 1885. Capt. Smith
later purchased the vessel around 1911
and remodeled her as a sloop in 1937. The
small structure at the junction of Union
and Water Streets was where Smith
designed and built boats; he was the
authorized local builder of the Brutal
Beasts. (Courtesy Chadwick Collection.)

**A PINT-SIZED CAPTAIN, 1937.** Like
father, like son, pint-sized Capt. "Dee"
Gardner, the son of Donald W. Gardner
Sr., commands the family yacht wearing
his dad's cap and a joyful expression.
(Courtesy Gardner Collection.)

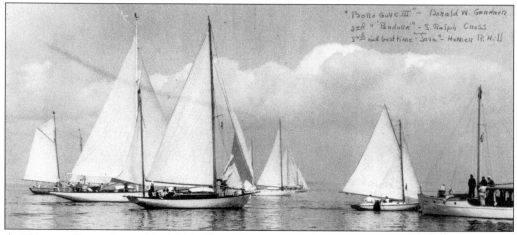

A 100-MILE RACE, JUNE 18, 1949. The inscription on this picture was written by Donald W. Gardner Sr., an advertising executive and commodore of the Boston Yacht Club in 1941 and 1942, during the Diamond Jubilee of the club. The inscription indicates that Gardner's sailboat *Boro Gove III* came in first in the race from Boston to Peaked Hill Bar off Gloucester. In 1951, the Gardner family was named the "All-American Boating Family" at the New York Boat Show. (Courtesy Gardner Collection.)

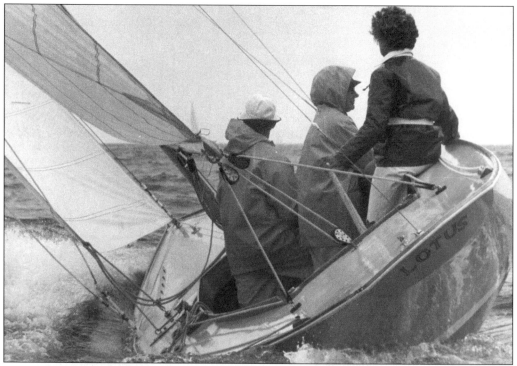

THE *LOTUS LADY*. Betty Pleasants checks the starboard side of her yacht during a squall as the boat beats for the windward mark. The wife of Lawrence "Pem" Pleasants moved from the Herreshoff 12 1/2 class to Shields Class competition the previous summer. During Marblehead's 57th Race Week in 1946, the International One-Designs saw competitors such as Barbara Wood, who sailed the *Saga*, win the "Eastern" trophy for the most consistent performance. (August, 1969 photograph by Joseph E. Noel; courtesy Chadwick Collection.)

# Six

# MISCELLANEOUS
# WATER VIEWS

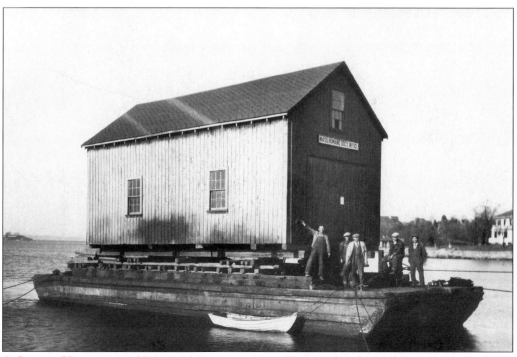

A LOCAL VERSION OF NOAH'S ARK, C. 1920S. "Topsy" Goodwin's barge transported this lifeboat shed, owned by the Massachusetts Humane Society, from its former site next to the Corinthian Yacht Club to its new location near Riverhead Beach. With the addition of animals, one might envision this to be a modern-day biblical ark. (Courtesy Chadwick Collection.)

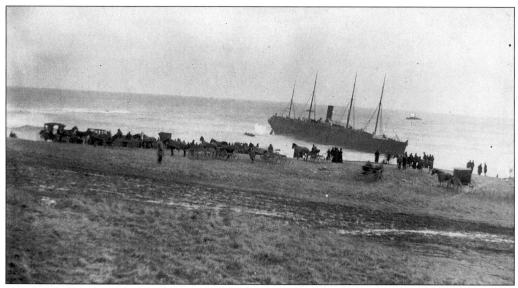

**THE GROUNDING OF THE NORSEMAN, MARCH 29, 1899.** "Tom Moore's Rocks" off Long Beach on the Atlantic Ocean side of Marblehead Neck was the scene of great excitement when the iron-and-steel hulled *Norseman*, bound from Liverpool, England, to Boston ran aground in the early morning hours in a dense fog. A few days later, tugboats from Boston freed the 392-foot British steamer and towed it to the city for necessary repairs. (Courtesy Goddard Collection.)

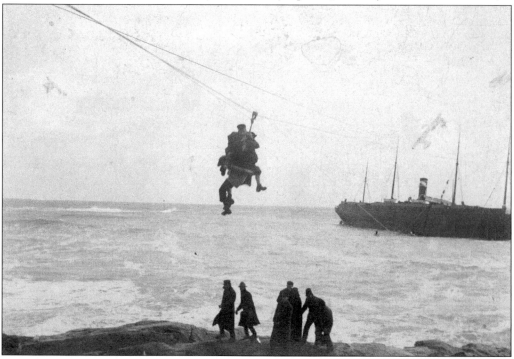

**SAVED BY THE BREECHES BUOY, MARCH 29,1899.** With assistance from the Massachusetts Humane Society's Little Harbor crew, all 101 people on board the *Norseman* were saved. At least 88 of the survivors were hauled to shore using the ingenious apparatus known as the breeches buoy. (Courtesy Chadwick Collection.)

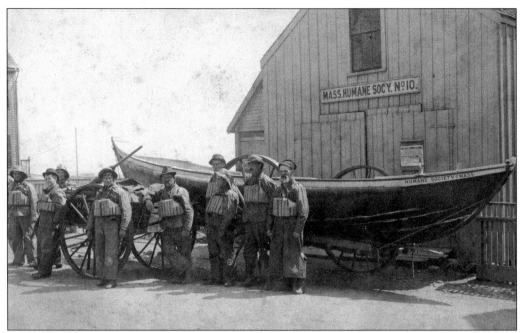

**THE MARBLEHEAD STATION OF THE MASSACHUSETTS HUMANE SOCIETY (MHS), 1899.** The station's surf boat is a modification of the Greathead lifesaving boat that originated in England in the early 1800s. Possibly a new boat, to replace a similar one damaged beyond repair, it was built at the Graves Yacht Yard. The last surf boat used by the MHS at Marblehead was donated to Mystic Seaport Museum, at Mystic, Connecticut, in 1972; it has since been restored and is in the Small Craft Collection. (Courtesy Chadwick Collection.)

**A LIFESAVING DRILL, C. 1915.** Members of the Massachusetts Humane Society's Little Harbor station practice in calm water along the shoreline of Peach's Point. On June 19, 1906, the crew of boat No. 10 received a reward for assistance to the schooner *Willie Irving*. (Courtesy Hammond Collection.)

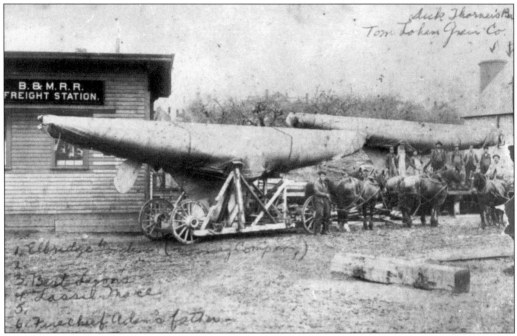

**ALL WRAPPED AND READY FOR SHIPMENT, C. 1909.** Workmen employed by Woodfin Movers have transported the newly "mummified" *Thea* (foreground) and another sailboat built at the Graves Yacht Yard to the freight station for their eventual Lake Erie destination. A barn and a grain company owned by Dick Thorner and Tom Lohan are at the extreme right of the picture. (Courtesy Chadwick Collection.)

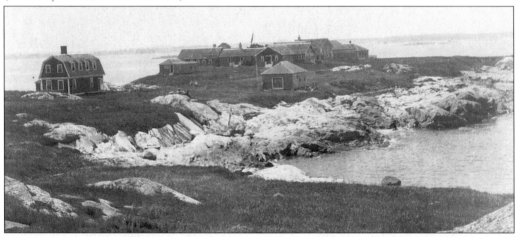

**CHILDREN'S ISLAND.** The 29-acre island located about a mile off Marblehead has had several name and function changes since Robert Cotta from Salem grazed his sheep there during the mid-17th century. It is believed that his name, either misspelled or shortened, became "Cat" Island, which is how it is known to fishermen, sailors, and historians (who prefer that name). A smallpox hospital was established there in 1773, and the Lowell Island Hotel was erected there in the 1850s. In 1878, a sanitarium for crippled children was established through the generosity of a local summer resident, Samuel B. Rindge. Used as such through the early 20th century, the island is now owned by the YMCA and flourishes as a summer camp. (Early-20th-century postcard; courtesy Maurias Collection.)

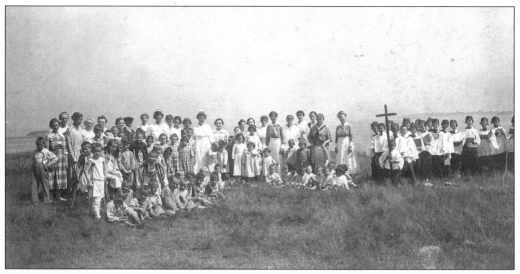

**A Group Portrait on Children's Island.** Nurses, volunteers, and choristers from a local church stand with crippled and underprivileged children from Boston neighborhoods who are delighted to be out-of-doors in the fresh air. Capt. William Klink took children to the island and back in his dory before 1889, and later the *Pelican*, a steam launch, safely carried them from the Transportation Company's headquarters at Tucker's Wharf. (Early-20th-century photograph; courtesy Hammond Collection.)

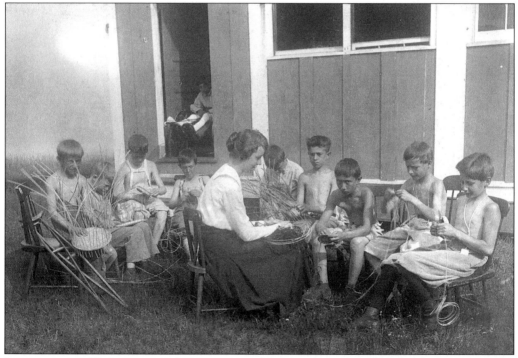

**Learning a Handcraft.** An attractive young volunteer patiently demonstrates the technique of making a basket to a group of boys, most of whom are really interested in the project. As a college student, Betty Greenleaf was a volunteer along with town ladies to help disadvantaged children. (Early-20th-century photograph; courtesy Hammond Collection.)

125

**A MARBLEHEAD MERMAID, 1907 POSTCARD.** The captains of the yachts in the background of this rare piece of ephemera were not as lucky as the sender of this greeting who spied the sultry Gibsonesque mermaid basking in the surging surf of Marblehead Harbor. (Courtesy McGrath Collection.)

**CELEBRATING AFTER THE "GREAT RACE," C. 1973.** A beaming Rick Anderson of Marblehead unwinds to the lively music at Devereux Beach after finishing the race; this annual event was later curtailed by town selectmen when overly large crowds became unwieldy and intoxicated there. Initiated by Kenneth Duncan, who owned "Maddie's" Sail Loft on State Street, the race ended there prior to its beach move. Whether on foot, roller skates, on one bicycle (or part of a 10-man bicycle group known as the "killer bees"), the highlights of the Great Race are remembered by all who attended this summertime happening. (Courtesy Chadwick Collection.)

**A Sheet Music Cover, 1916.** Miss Dora Blackford was inspired by the quaint town to compose a song relating to what some might refer to as a melancholy time of the year, when many yachting enthusiasts have put their vessels in dry dock and their dreams of freedom at sea on hold until the following glorious season beckons them to Marblehead Harbor once again.

# Acknowledgments

The kind and generous inhabitants of Marblehead who loaned the author photographs, ephemera, and knowledge for the first volume of this pictorial history of the town were equally supportive the second time around. Many thanks also go to the following notable individuals: Edith B. Abbot; Mr. and Mrs. Garrett D. Bowne; Mr. and Mrs. Norris L. Bull Jr.; Mr. and Mrs. Richard Case; Benjamin R. Chadwick; Thomas L. Creamer; Louise Graves Martin Cutler; Mr. and Mrs. Frederick W.E. Cuzner; Frederick H. Goddard; Marion Gosling; the late Robert Selman Graves; Mr. and Mrs. James R. Hammond; Nicholas Hammond; Roblee Hoffman; Frederic W. Kinsley; Mrs. Russell W. Knight; Selina F. Little; Charles F. Maurais; Dorothy Fogg Miles; Daniel R. McDougall; Vincent F. McGrath; Mr. and Mrs. Peter Neily; Harriet Chadwick Nichols; Mr. and Mrs. Alexander Parker; Stanley S. Sacks; Stephen J. Schier; Thomas T. Sleeper; Mrs. Samuel E. Swasey; Mr. and Mrs. Robert Swift; Todd Waller; Nathalie Frost Woods; and Margaretta Chamberlain Wyzanski.

Grateful appreciation goes to Judy Anderson of the Marblehead Historical Society, and to Donald A. Doliber Sr., who was named "Outstanding Teacher of American History in the United States" in 1982. Model ship builder and maritime historian Erik A.R. Ronnberg Jr., a native of Rockport, Massachusetts, shed important light on various aspects of the manuscript relating to the construction and history of Marblehead-owned vessels, and to Erik this landlubber author is also indebted.

# Bibliography

Barber, John Warner. *Historical Collections of Every Town in Massachusetts*. Worcester, Mass.: Dorr, Howland & Co., 1839.

Ferguson, David L. *Cleopatra's Barge: The Crowninshield Story*. Boston, Mass.: Little, Brown and Company, 1976.

Garland, Joseph E. *The Eastern Yacht Club*. Marblehead, Mass.: The Eastern Yacht Club, 1989.

Gray, Thomas E. *The Founding of Marblehead*. Baltimore, Md.: Gateway Press Inc., 1984.

Kimball, F.R. *Handbook of Marblehead Neck*. Boston, Mass.: Published at 31 Milk Street, 1882.

Roads, Samuel, Jr. *A Guide to Marblehead*. Marblehead, Mass.: Charles H. Litchman, 1881.

———. *The Salem Directory . . . Also . . . for . . . Marblehead*. Boston, Mass.: 1886.

Shanabrook, Paul E. *The Boston: A History of the Boston Yacht Club (1866–1979)*. Boston, Mass.: The Boston Yacht Club, 1979.

Taylor, William H. and Rosenfeld, Stanley. *The Story of American Yachting Told in Pictures*. New York: Appleton-Century-Crofts Inc., 1958.

Thayer, Elynore R. *Corinthian Yacht Club Year Book, 1985*. Marblehead Neck, Mass.: Corinthian Yacht Club.

300th Anniversary Committee. *Marblehead Tercentenary, 1649–1949*. Marblehead, Mass.: Town of Marblehead, 1949.